Art of Sketching

Translated from the Spanish by Natalia Tizon.

Library of Congress Cataloging-in-Publication Data available

10 9 8 7 6 5 4 3 2 1

Published in 2007 by Sterling Publishing Co., Inc.
387 Park Avenue South, New York, NY 10016
Originally published in Spain under the title *Dibujo de Apuntes*
© 2006 Parramón Ediciones, S.A. Ronda de Sant Pere, 5. 4th floor
08010 Barcelona (Spain)
English translation copyright © 2007 by Sterling Publishing Co., Inc.
Distributed in Canada by Sterling Publishing
C/o Canadian Manda Group, 165 Dufferin Street
Toronto, Ontario, Canada M6K 3H6
Distributed in the United Kingdom by GMC Distribution Services
Castle Place, 166 High Street, Lewes, East Sussex, England BN7 1XU
Distributed in Australia by Capricorn Link (Australia) Pty. Ltd.
P.O. Box 704, Windsor, NSW 2756, Australia

Printed in China
All rights reserved

Sterling ISBN-13: 978-1-4027-4423-5
 ISBN-10: 1-4027-4423-4

For information about custom editions, special sales, premium and
corporate purchases, please contact Sterling Special Sales
Department at 800-805-5489 or specialsales@sterlingpub.com.

Sketch Credits:
*Mercedes Gaspar: Pages 9, 10, 11, 25, 26, 30, 31, 34, 37, 38, 40, 55, 57, 58,
60, 61, 64, 65, 67, 71, 73, 77, 83, 86 ,87, 89, 91, 93, 102, 103, 104, 105, 109,
111, 112, 113, 114, 115, 117, 118, 120, 121, 122, 123, 130, 133 to 135, 140 to
143, 148 to 151
Gabriel Martín Roig: Pages 2, 7, 12, 19, 20, 24, 25, 28, 31, 32, 35, 39, 41, 43,
44, 45, 47, 51, 56, 59, 63, 70, 71, 72, 74, 75, 78, 81, 84, 86, 87, 88, 90, 91, 94,
95, 102, 103, 108, 110, 126 to 129, 152 to 157
Óscar Sanchís: Pages 6, 15, 16, 19, 21, 22, 27, 27, 28, 29, 33, 41, 42, 45, 49,
50, 52, 59, 62, 63, 65, 66, 68, 69, 71, 75, 80, 83, 84, 85, 89, 91, 92, 107, 112,
113, 115, 116, 118, 119, 121, 131, 132, 136 to 139, 144 to 147

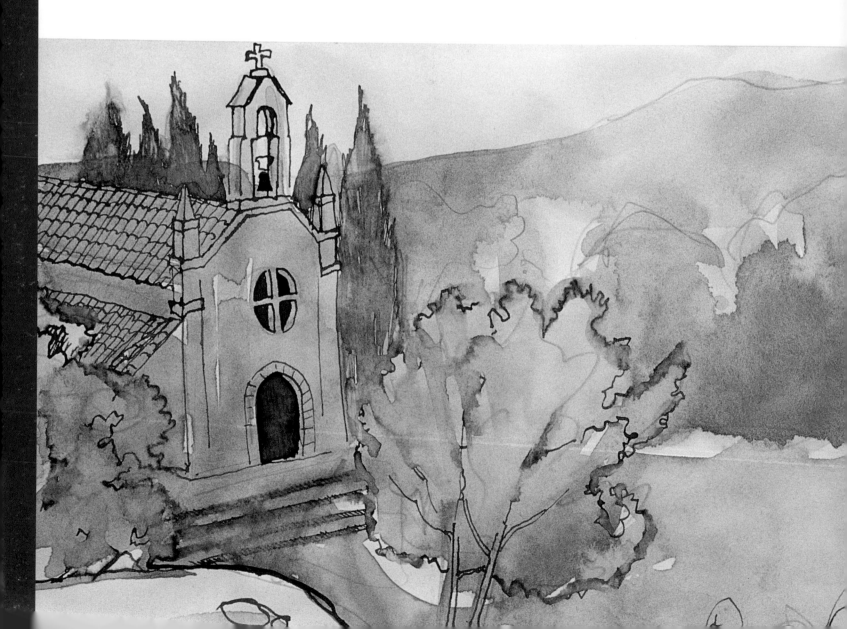

Art of Sketching

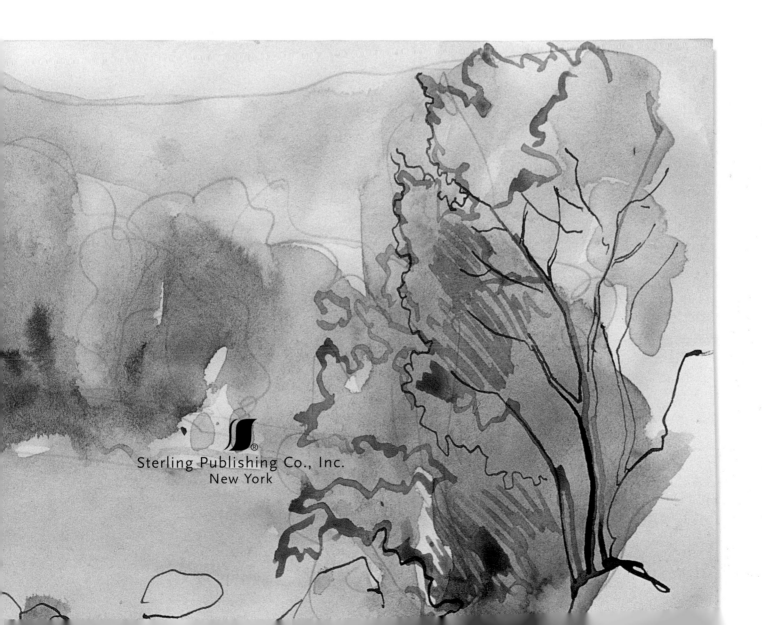

Sterling Publishing Co., Inc.
New York

Con-tents

Introduction

Thinking with a Pencil. Agile Lines

Providing a precise definition of the word *sketch* is very difficult. Sketches are not just rapidly executed renderings that use a specific technique or are done to a certain level of completion. Technically, a sketch is a concise representation whose primary purpose is to capture the basic features of a model, a moment in time, or a spontaneous movement, which compels graphic media to be used economically. It captures a form in just a few lines, but with a lot of expression.

Sketches are not just the preliminary renderings of a more ambitious work of art that generally is done in oil or acrylic. Sketches have their own reason for being as complete renderings. A sketch is an end in itself, a type of drawing with its own identity, a versatile and gratifying art form, accessible to everyone.

Sketching is a good way to practice drawing, develop your ability to improvise, and gather important information and develop ideas. Making a sketch requires thinking with a pencil, that is, letting the pencil work impulsively and not very rationally, freeing it from the control of the mind. It's a great opportunity to work quickly, make instinctive lines, and expand upon the techniques you have learned without a fear of failure and without the constrictions of conventional drawing and academic drawing techniques. This apparent freedom prevents the artist from completely controlling the end result. Each sketch is unique and unexpected. This outcome means that this type of drawing has an element of the uncontrollable: The hand moves in a barely foreseen way; the sketch begins in unforeseen places; it sometimes advances with continuity, and, at other times, it progresses in intervals. Sketching requires making continual adjustments. Inevitably, objects in sketches attain a new level of stability.

Sketches let your hand move freely and impulsively on the paper. Many times, this spontaneity means that the result can only be understood by the artist.

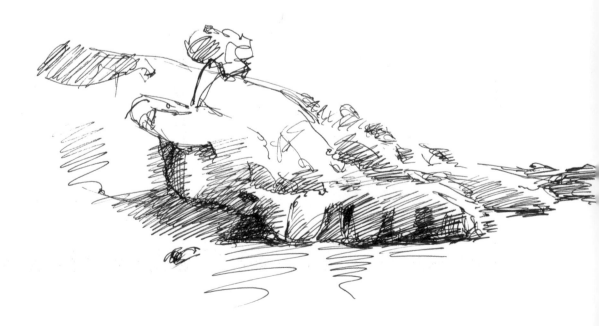

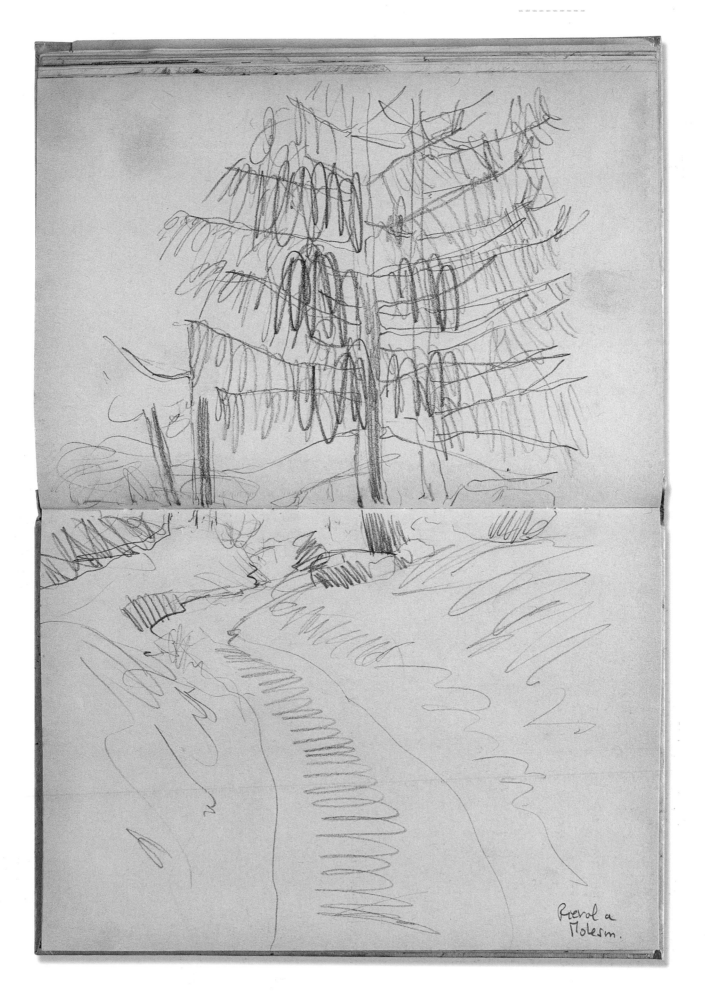

Reval a
Molesm.

Rough drafts

and simplified design of the model

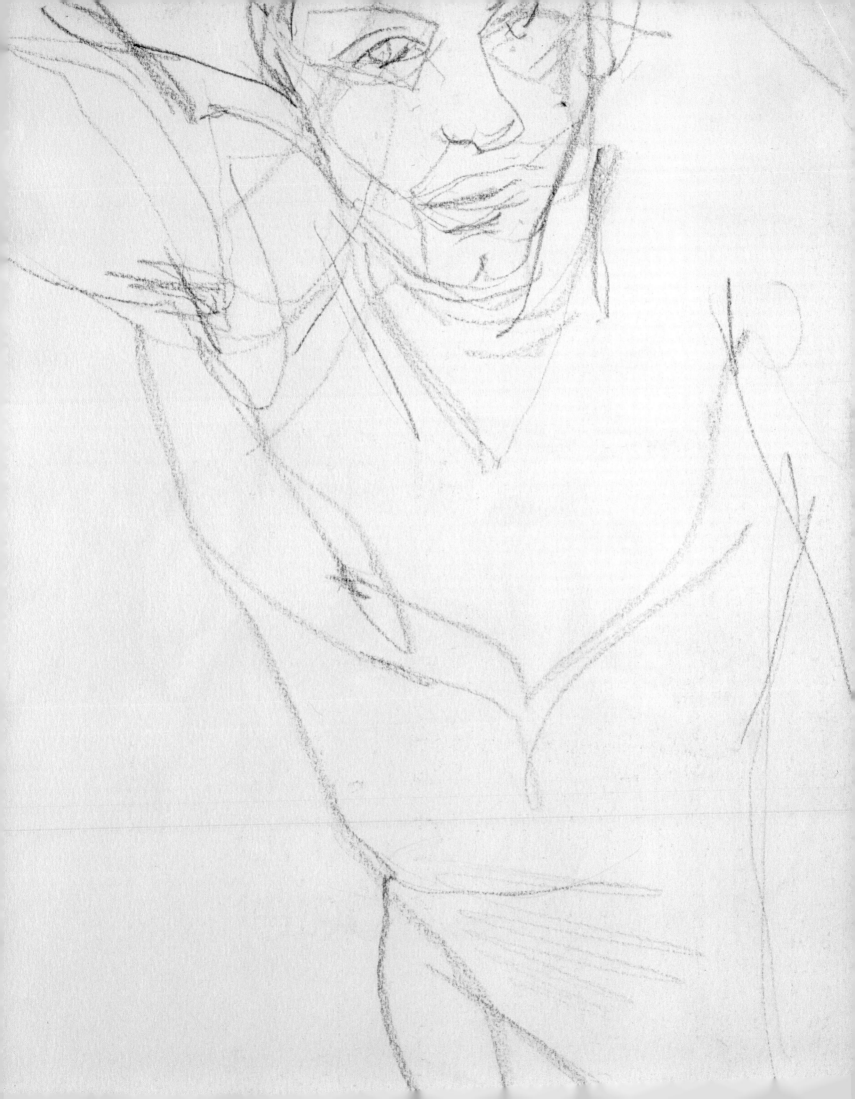

Subject, frame, and

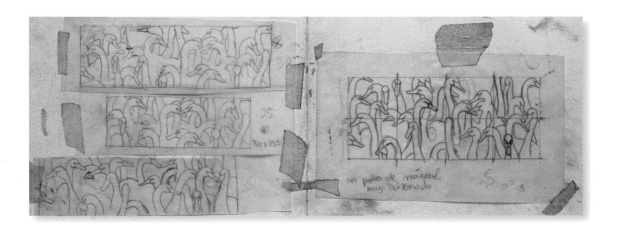

MERCEDES GASPAR. STUDY OF A GROUP OF GEESE, 2002.
GRAPHITE PENCIL ON VEGETABLE PAPER.

composition.
Your visual field
is very broad;

however, your sketch paper is usually small,
and it allows you to draw only a small part of what you see. It is important to se-
lect a subject carefully and develop the composition thoroughly to reduce the vi-
sual angle, so that your sketch focuses on only a fraction of what you have in
front of your eyes.

 To limit the subject, you must carefully study composition techniques, ana-
lyze the possibilities of the model, reduce the process of framing the model to a
minimal expression, and work a series of drawings in which you systematically
modify the frame and the point of view to find the best representation possible.
This method of working forces you to contemplate the model in a very analytical
way and to sketch in a very cursory way.

analyzing and Owning the subject

You are aware that you will not be able to include the entire landscape in front of you in your sketch. You must study the model thoroughly, to understand it instead of copying it.

THINK BEFORE YOU DRAW
Before you begin to draw, you must think about your sketch. Ideally, you should spend three-quarters of the time thinking about the sketch and one-quarter of the time sketching. The quality of your observations is more valuable than your technical skills. First, identify exactly what you are interested in and what combination of elements makes the subject more attractive to you. These factors will help you reproduce it correctly on paper.

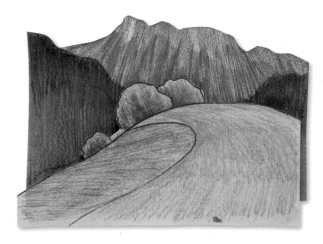

Observe the model attentively and decide how important the foreground and background are.

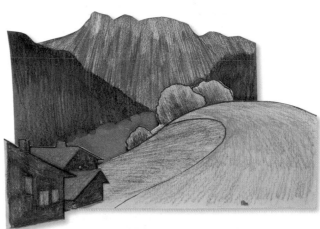

You can include or omit a group of houses on the left to achieve more or less imbalance in the composition.

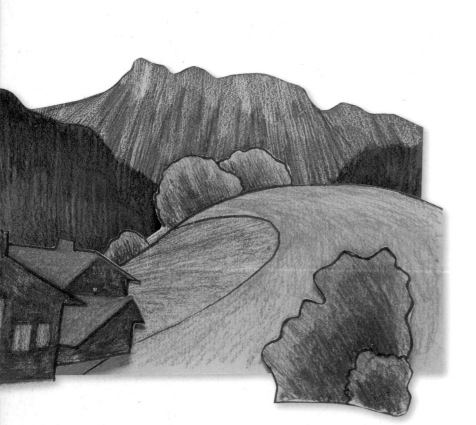

By drawing a tree in the foreground, you are enhancing the sketch's depth. Ultimately, any slight manipulation of the drawing will alter the final result. This simple fact emphasizes the importance of planning your sketch.

REJECTING THE SERVILE LOOK

The point of sketching is not to copy what you see, but to understand, memorize, and draw in a very personal way, to *avoid* copying from the model. A good way to develop both your ability to observe and your ability to recall is to focus on an object for a couple of minutes, trying to retain the most detail possible to define it—shape, proportions, texture, and so forth—and then draw it on the paper without looking at the model again.

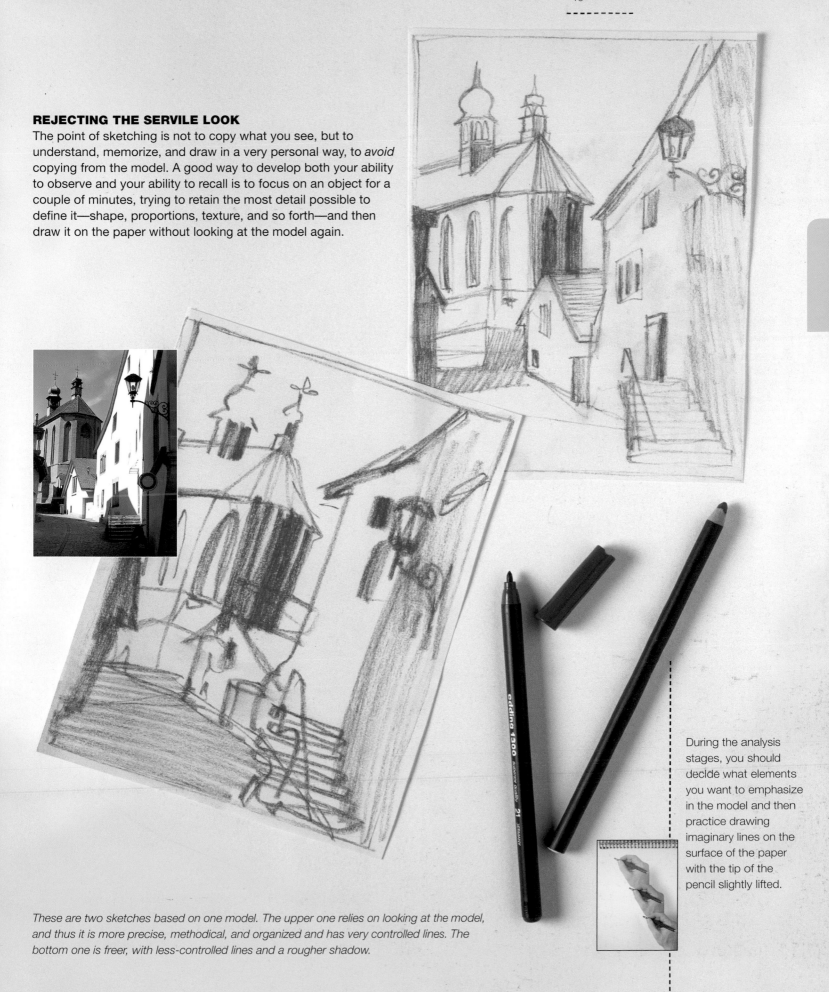

These are two sketches based on one model. The upper one relies on looking at the model, and thus it is more precise, methodical, and organized and has very controlled lines. The bottom one is freer, with less-controlled lines and a rougher shadow.

During the analysis stages, you should decide what elements you want to emphasize in the model and then practice drawing imaginary lines on the surface of the paper with the tip of the pencil slightly lifted.

Studying and trying to own what you have observed is a way to anticipate the subject, a step that all artists must take before sketching. This process allows you to evaluate the subject, gather information, and exercise your skills of interpretation to prevent the sketch from becoming bogged down in too many technical details.

studying, Processing,
and remembering what you have observed

GATHERING DIFFERENT ASPECTS OF THE SUBJECT

One way to get the desired outcome of an interesting analytical study, with the optimal composition of the subject matter, is to make a series of drawings that reflect different aspects of the same subject. In these quick, rudimentary sketches, you should try to change the composition or viewpoint; likewise, gather many different aspects of one subject, changing the frame and even varying the technique and drawing methods used.

These sketches are very quick and rudimentary, by no means intended to be concrete or final. Their primary function is for composition. This manner of sketching is one way to get to the basic lines that define the model.

You don't have to work with just lines when making your studies. You can also use broad, artificial shadows to get the desired result.

DISCORDANT ELEMENTS

When making preparatory sketches of your model, you may find discordant elements that attract your attention. These may distract your focus from the main subject and not add anything interesting to the drawing. Remember that no rule obligates you to include something just because it is present in the model.

NOTES TO REMEMBER WHAT YOU SAW

To remember and better process what you observe, you can write notes in the drawing that add information on colors and textures. You can also introduce tone values with pencil or charcoal and place them in the margins of the drawing much like a value scale. A good time to use these notes and values is when you are sketching spontaneously, are in a hurry, or both. Time constraints or other limitations might mean that you have to work in black and white when you need a color reference as well.

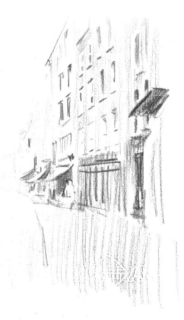

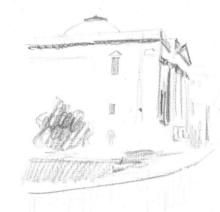

Compare the photographic model to the sketch. You can see that the artist has eliminated some discordant or disturbing elements—namely, the cars and the pedestrians on the street. She has eliminated them to maximize the depth and give a more desolate nuance to the urban view.

Carry a sketchbook with you when you visit museums, to sketch your favorite art pieces. You can add written notes that provide additional information.

obtaining Measurements quickly

artists don't have to draw a basic schematic or diagram to build a more complex sketch. However, in certain sketches, especially those that involve urban scenes and architectural landscapes, beginning with a mental calculation of measurements and proportions might be useful.

Architectural drawings allow you to place the main lines of the sketch, maintaining proportions.

ARCHITECTURAL DRAWINGS

Sketches done by architecture students or architects are precise in terms of perspective, measurements, and proportions. The need to be precise promotes the habit of measuring and establishing relationships before any detailed drawing is done. So, planning and initial consideration and analysis of the subject are important, as your impressions will form the basis of the lines of construction and will ultimately contribute to the precision, weight, and solidity of the final artwork.

This drawing is done with a pencil, using soft and straight lines that sketch the planes and the distinctive shapes in the model.

Observe the precision of these urban sketches, where the perspective and geometry of the buildings become very important.

Working with straight lines will give you little margin for error and will help you depict models such as this one, where the different planes of the houses and roofs are superimposed, creating a very distinctive rhythm.

REFERENCE POINTS

A composition always has some reference points to help you distribute the different elements of the model on your paper. You can make small marks and directional lines that help you structure your model with the right proportions and create your composition.

ADJUSTING YOUR FRAME WITH A VIEWFINDER

Using two pieces of cardboard or bristol board in an L shape, you can create a viewfinder. You will then have your own "frame" or "window." Hold it in front of you, and with one eye closed, look at your model through it. You can make small marks on the edges of your viewfinder to easily measure and control the scale of the elements you are going to draw.

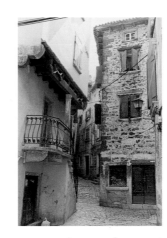

Using simple perspective lines as a preparatory sketch is helpful, because they will help you structure and compose the scene.

Compare the sketch to the photograph. Notice that certain line intersections or corners with pronounced angles have been highlighted. You should use them as reference points to create your sketch. By exaggerating the angle or the incline of some of these lines, you will achieve more expression in the drawing.

To create a viewfinder or frame, take two pieces of cardboard or bristol board of a dark color and form an L. The marks made on the inside edge of the frame can be your reference to create proportions.

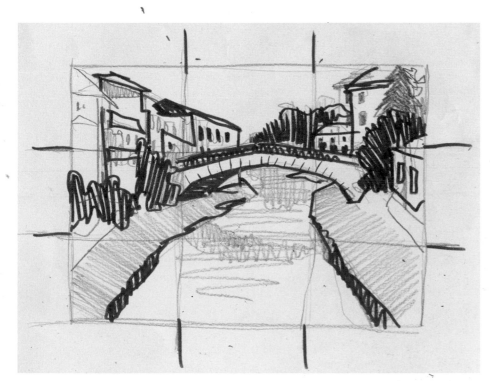

This sketch has been done using a viewfinder. The lines of the viewfinder become a reference for distributing the elements in the composition.

rough Drafts,

preparatory drawings

to draw something very faithful to your model, you can begin the sketch by projecting several soft lines that help you place the foreground and the background correctly on the paper. Doing so will help you achieve the right forms and sizes. This type of rough drawing will give you a structure on which you can build more precise forms.

SKETCHES OF SKETCHES

Rough drafts are preliminary sketches of sketches. They contain three or four imprecise, almost abstract lines, drawn very softly on the paper. This task should take just a few seconds. They have such a high degree of synthesis (in fact, they could be considered almost abstract) that most of them cannot be understood by anyone other than the artist.

After analyzing the model, you can begin to sketch it. The first drawing must be very basic and can be done very softly with a pencil. The drawings shown here have stronger lines than normal.

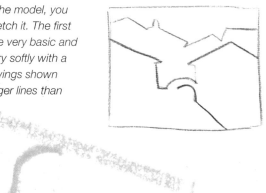

Rough drafts are a sketch of the sketch, a preliminary composition that defines the most important forms and distinguishes the foreground from the background.

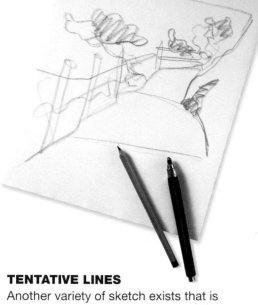

A tentative line. It is a soft line, done by barely lifting the tip of the pencil from the paper.

If your sketches are small, just a few inches wide, you can complete many sketches in a few seconds and eliminate details very easily.

TENTATIVE LINES

Another variety of sketch exists that is intended to be less analytical and precise and more spontaneous and informal. With this type of sketch, you organize the drawing with soft "tentative lines," tilting the tip of the pencil. You create these lines almost without thought, letting your hand slide on the paper as you raise and lower your head, keeping an eye on the paper and also looking at the model.

The line must almost caress the paper, forming soft curves and waves and superimposed lines.

Tentative lines are sinuous, imprecise, and not very defined.

Intuition and Automatism

in Sketches.

In sketches, a composition and distribution

of elements can be developed intuitively and without much planning. Instead of being a disadvantage, this process must be used as a way to let the uncontrollable take control of the drawing. This way of planning the sketch has to be seen as your main ally for stimulating your imagination and enabling you to achieve different perspectives, frames, and unusual representations than you would have with a more analytical process.

Composition with *generic lines*

despite the freedom provided by sketches, you may need to plan the composition a little to correctly distribute the main forms and differentiate the planes. Although gridding is not very common in sketching, in some cases such diagrams and test lines are used in a way that does not corrupt or harm the work process.

DIVIDING INTO THIRDS

Before making any mark on the paper, you can divide the space into three parts, with soft horizontal and vertical lines. These divisions will create a basic grid that will help you to structure the model and the composition. They also help prevent symmetry in the sketch, because elements must coincide on top of or close to the intersection of the lines that divide the space.

1

1. Trace a grid on the paper by crossing two vertical and two horizontal lines.

2. After analyzing the model, determine which main elements compose your model. Modify the composition, making each element coincide with the intersection of the lines that form the grid.

2

3

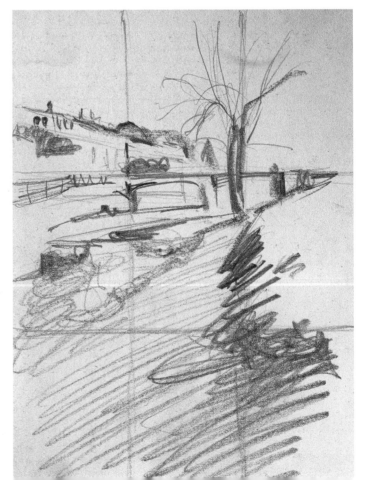

3. After sketching and applying some shadows, you can see that the general composition has been modified to achieve a more interesting and harmonious distribution.

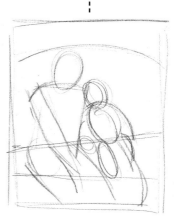

The tentative line is a soft tracing that follows the profile of the model, to frame it.

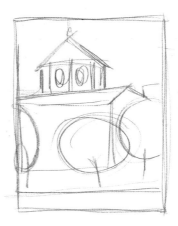

GENERIC MASSES AND COMPOSITION DIAGRAMS

If you do not have enough confidence to grid the sketch, you might want to distribute two or three generic contours so that the composition can be inferred. Doing so should not be difficult, because behind each motif hides a precise composition schema. These diagrams are interrelated, in general, with simple geometric shapes or diagonal compositional lines that coincide with the main lines in the subject.

Instead of applying the grid, establish the sketch using very simple geometric diagrams.

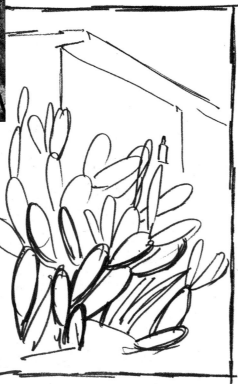

From a real model you can obtain some basic shapes, preferably geometric ones. You can continue working on this preparatory drawing until you finish the sketch.

The vegetation shapes lend themselves to geometric forms that make setting up the sketch much easier.

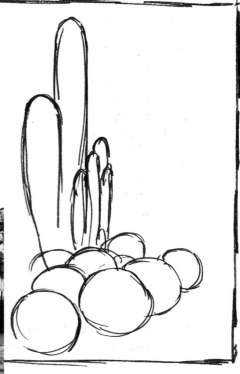

frequently, you will not have time to study all the compositional factors of the image because you intend to capture the main traits in a very expressive way. In these cases, planning the composition just involves making a few intuitive lines or sketching without planning.

intuitive composition,
when anarchy is in control,

ANARCHICAL DRAWING

With the intuitive composition, there are times when the drawing begins on one side of the paper and some of the components that you thought of including are left out. It does not matter: anarchy dominates over planning; the drawing is created and modified on the go. The only goal is to achieve a drawing with visual impact.

1. You can sketch without creating a guideline. Begin the drawing on one end and advance without fitting the dimensions on the paper.

2. As the drawing advances, you can modify the dimensions of the model at your discretion without including the whole model in the composition.

3. This sketch shows the tower cut by the edge of the paper. The composition gives a feeling of uncertainty, spontaneity, and lack of control.

1

3

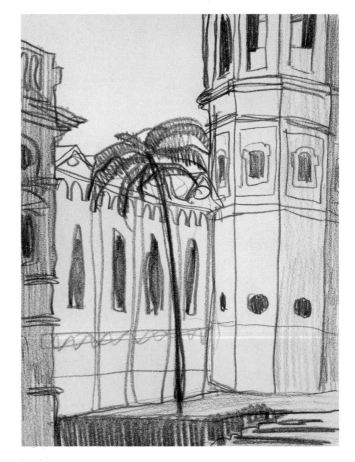

UNCONVENTIONAL COMPOSITIONS

In a sketch, the final result is less important than a finished drawing; the main appeal is to surprise the viewer with original frames. The purpose is to break traditional schemas and explore new compositions. The study of different frames or points of view of the model will allow you to know it better and to improve your composition skills, in addition to putting into practice an intuitive notion of the meanings of *grouping* and *composing*.

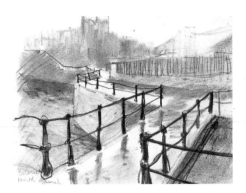

To achieve unique compositions, you must avoid symmetrical drawings. To counter this excessive balance, you must ensure that the elements on both sides of the line are different.

Sketching is not a matter of drawing everything you see. It is important to find or create frames to develop unique compositions.

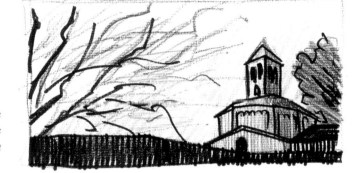

In your search for original compositions you cannot ignore surprising frames such as placing the subject of a landscape on one end of the paper.

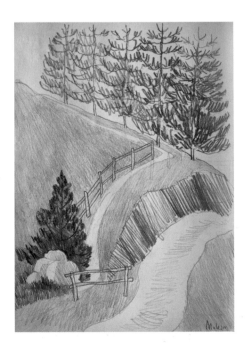

Drawings made from nature allow you to manipulate and transform the components to achieve a more attractive composition.

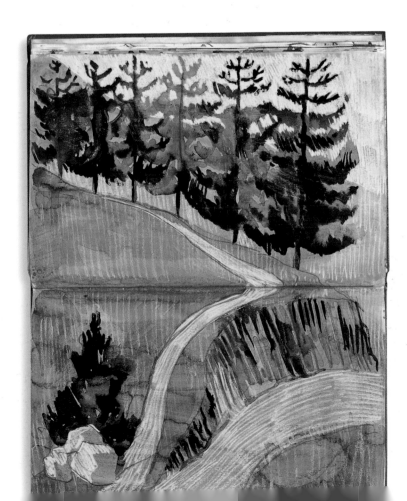

Back in your artist's studio you can further work on the sketch: you can repeat the previous model with new tools, and you can enhance the aspects that have attracted your attention the most.

Automatic drawing and blind drawing

refusing to plan your compositions can be extrapolated to automatic drawing, the product of inertia and the hand's mechanical movements. This lack of control is even more pronounced in blind drawing, an interesting exercise that frees the hand from the control of your eyes.

AUTOMATIC DRAWING
The practice of automatic drawing began with the theories of automation and is associated with surrealists. It is known for registering the arm's free movements, the artist's gestures, with lines that the hand does intuitively, almost without the artist's thought, in a psychomotor way. Automatic drawings can look like very elaborate drawings or errant drawings, products of the subconscious. Artists use this technique to include information in their notebooks that they would not have time to register completely.

Automatic drawings can become small notes in which the hand runs freely without apparent direction.

Creating sketches where the hand is faster than your thoughts is important, as it frees the hand from your mind's control.

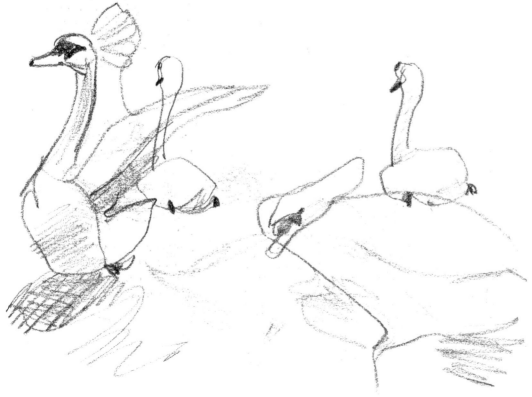

Once you know how to use the automatic technique, you can practice on models from nature, such as this group of swans.

BLIND DRAWING

Blind drawing gives, if possible, more autonomy to the hand. To practice blind drawing, sit in front of a model. Focus on it, and avoid looking at the paper while you are drawing. The paper must be outside your visual field. Focus on each shape of the model, details, wrinkles, folds, interior lines . . . and try to transfer those shapes to your hand as if it were functioning as a seismograph. The pencil reproduces what you see while you are looking at it. The tendency is for you to look down at the drawing, but you must resist this urge and maintain your focus on the model.

The finished drawing will reveal a network of lines without too much logic to it, but if you observe it, you will realize that those lines have an unusual beauty.

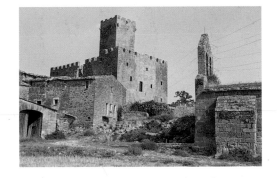

Through blind drawing we lose control over the reference points that add proportion, coherence, and cohesion to the drawing. This figure presents a dislocated face and apparent variations in the proportions of the facial features.

1. Start the drawing in front of the model, without looking at the paper. Begin drawing on one end, and control the progress from the corner of your eyes.

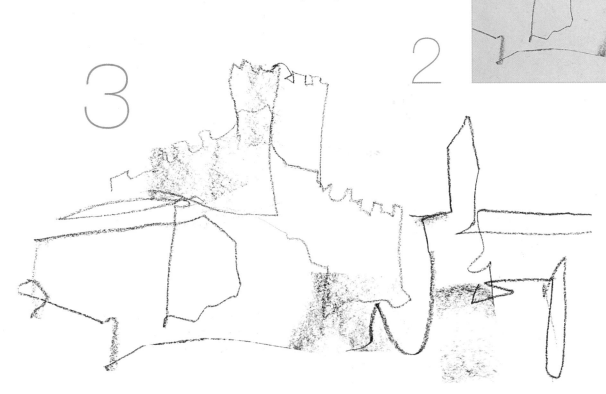

2. Do the work with one continuous line, using different thicknesses and intensity.

3. The complete blind sketch does not show accurate proportions, but it offers a very expressive interpretation of the model that is both ingenuous and cursory.

Scribbling,
uncontrolled lines

Some subjects are more prone to being rendered with scribbling than are others. Vegetation, landscapes, and figures are the best subjects for this technique, whereas urban landscapes, perspective, and the geometry of buildings are much more imposing.

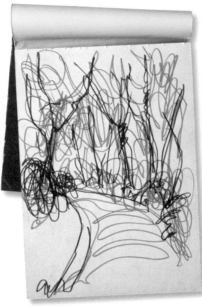

When you listen to a song or melody you like, you may tap your foot or rap on a table with your fingertips. A similar process occurs when you scribble on a piece of paper while you talk on the phone. These movements are practiced unconsciously and involve repetitive gestures and movement. Use this energy to develop interesting sketches.

ALMOST UNINTENTIONALLY

Scribbles are lines drawn energetically. The artist does them almost unintentionally, without being aware of them, letting the hand take its course without obeying the renderer's orders. This impulse translates onto the paper as an inscription of quickly created physical gestures. Many artists scribble as a quick drawing technique, with an unconscious motivation. In contrast to blind drawing, this technique requires speed and good control of the lines.

A ballpoint pen is one of the preferred tools for scribbling. It allows you to create lines and curves very quickly.

Scribbles are personal visual notes that force you to develop a great ability for remembering the model and using different line techniques.

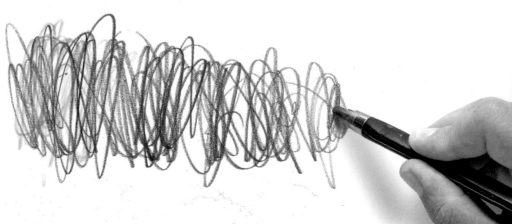

PRELIMINARY SKETCHES

Scribbling is very useful in "preliminary sketches," those
sketches you do to prepare for additional drawing. These
warm-up sketches enable you to have a first contact with the
model or the tool used and to concentrate so you can begin
your work in earnest. You can also learn and benefit from
these types of sketches. Because these are preliminary
sketches, you do not need to worry about correcting errors.
If you make a mistake, just take another
piece of paper and begin again with
determination and spontaneity.

*You should use the
quick work of scribbling
to create preliminary
sketches as a warm-up
before a day of
sketching outdoors.*

quick drawings
speed and technical skills

You often have to sketch very quickly, especially when your model moves. Work in sketching is typically done quickly. It may seem difficult at first, because speed detracts from precision, but this should not concern you, as your skills will improve with practice.

DRAWING QUICKLY

Drawing quickly is the way to obtain more spontaneity and achieve a refreshing approach. At first, it offers poor artistic results and will perhaps disappoint you, but the effort is time well spent. You will get used to reacting quickly when in front of a model and avoiding drawing details or sketches that are too planned. Your mind may sometimes be too rational and afraid of error, and it can slow down your hand. The best way to draw quickly is to avoid lifting the tip of the pencil. Shadows will be done without precision, covering only the more intense areas.

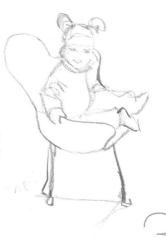

This sketch done with a marker took about 45 seconds. It is made up of just a few lines for the structure of the building and a stripe pattern in the shaded area.

In one minute, with a soft and variable line, represent this girl sitting down on a chair.

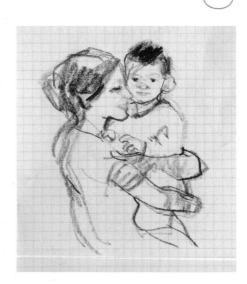

1. The best way to understand this technique is to practice it. This model was done with a tilted pencil in 30 seconds.

2. Take another 30 seconds to go over the lines to differentiate the body from the arms.

3. Finally, in one minute or less, apply shadows to the hair and the arms and sketch the facial features.

This figure of an elderly lady is somewhat distorted and has diluted contours, to achieve expression. The ability to draw using this technique freely and with sensibility evolves after a lot of practice and experience.

AN EXPRESSIVE DISTORTION

When you draw very quickly, accurate rendering of the proportions is beyond your control. You will not have time to notice or to measure the proportions. Unless you are an expert artist, you will not be able to avoid introducing distortion. Therefore, it is advisable to enhance the expression with a premeditated distortion.

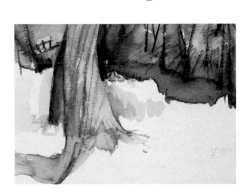

The tree trunk in the foreground stands out for the viewer and takes importance away from the rest of the forest.

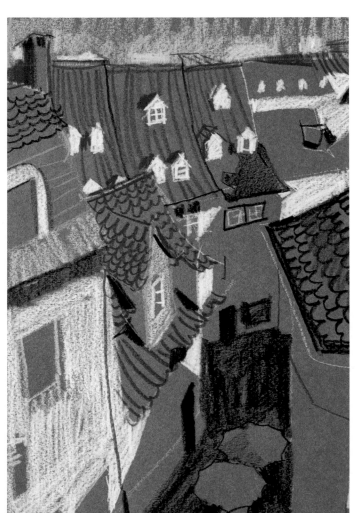

These roofs are completely out of proportion to one another and do not follow the rules of perspective. Together with the vivid lines, they give a lack of stability and dynamism to the drawing.

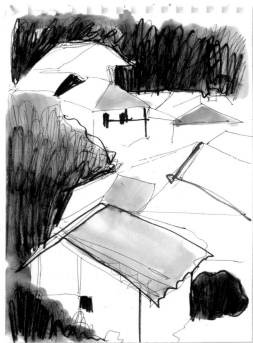

View of an alley sketched with strong light-and-shadow contrasts. Drawings also can show mood and emotions and can be created subjectively and expressively.

rhythm, which comes from the world of music, is an important concept in drawing. It is achieved by planning dynamic lines or repeating one theme, provoking a rhythmic sequence in the drawing. The distribution of these dynamic patterns or reiterative forms determines the attractiveness and the interest of the rhythm in the drawing.

the importance
of rhythm

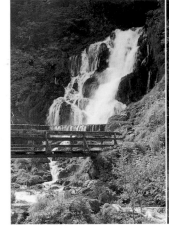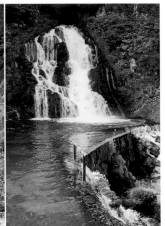

RHYTHMIC LINE
The long lines in a drawing are the ones that mark the fundamental trajectories and determine the tempo, the rhythm, and the distribution of the other shapes in the composition. You must identify these lines in the model and enhance them, even exaggerate them, to highlight the rhythm of the composition and enrich the presentation.

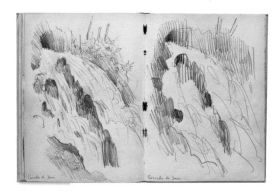

Two sketches of a small waterfall sketched from nature. The rhythm and speed of the water are achieved by superimposing curved lines at a high speed.

In these two preliminary sketches of a waterfall, the artist's intention is to maximize, with a few lines, the rhythm of the model.

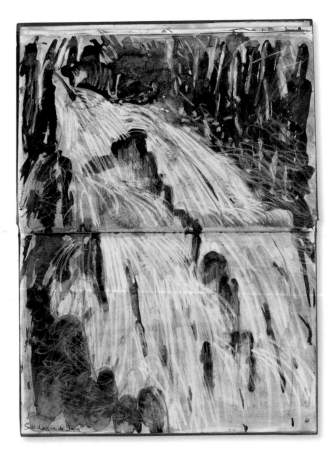

With the previous sketches, draw a new sketch using India ink and white pencil on colored paper. The rhythm and intensity that you give to the white pencil lines are critical in representing the falling water.

LINE OF FORCE

For a model to take on a balanced and rhythmical composition, it is necessary to have an internal stroke, an imaginary line that goes along the drawing to enhance the rhythm. This structural line, known as an action line, is the base drawing on which we articulate the rest of the drawing.

SPONTANEOUS DRAWINGS

Spontaneous drawings are based in the rhythmical exaggeration of the lines. They are drawings done violently, so that the marks on the paper become an inscription of the physical gestures, the emotions, and the artist's personality.

A spontaneous drawing does not intend to describe the model in detail; rather, it uses broad brushstrokes to convey its essence.

Lines of force can be found in any motif; they need only be identified to be enhanced. Here, they are seen in the perspective of the street and the two superimposed arches.

The sketch must not be rigid. On the contrary, the tip of the brush has to answer to the artist's wide hand gestures, dancing on the paper.

Lines of force are tensions within the models. They are critical for giving rhythm and expression to the drawing.

The brush is the most used tool in sketching, allowing an easy flow and greater control of the line.

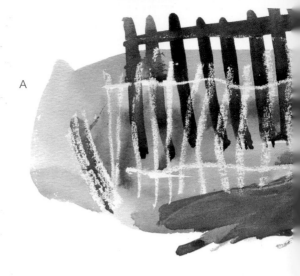

the time Factor
in sketching

quick sketches are often done in a series to capture immutable points in time. These sketches can function like "notes," which record and rationalize each particular moment.

IN JUST A FEW SECONDS

Time is one of the essential aspects in sketching. The necessity of having to make a visual selection and using the techniques you have available to approximate it when you have only a few seconds or minutes to draw gives vitality to the work and enables you to improve as an artist.

Even if you have enough time to draw, you do not need to create a detailed and complete drawing. A good way to learn to draw quickly is to draw the same subject once a day for a week. As you become familiar with the model, the time you need to draw will decrease. With practice, your hand becomes more confident and learns to find solutions for any of the composition's requirements. Also, as you discover more information about the subject, the objectives and interest change and you plan other ways to note that information.

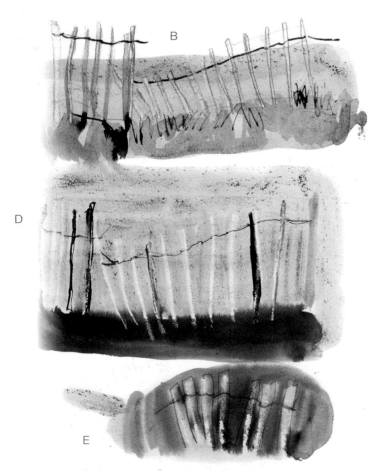

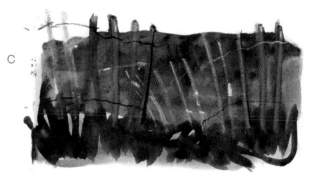

A. First day. Draw a simple motif and spend a few minutes a day on it, and you will see that the first version does not at all resemble the one done four days later.
B. Second day. The model, initially colored, has become very monochromatic and cursory, perhaps excessively so.
C. Third day. It seems that the monochromatic effect is the dominant one in your sketch. There is a higher graphic interest, although the sketch is too black.
D. Fourth day. The fence is highlighted with a lighter tone, and two tones of gray are now evident. White colored pencil is applied to the dry ink wash and black ink lines.
E. Fifth day. The sketch now makes more sense. The ink wash merges better with the lines that define the wooden fence. It is evident that repeating a motif results in an improvement.

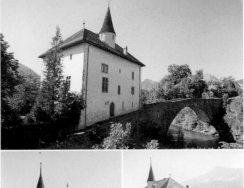

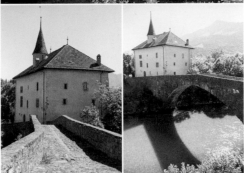

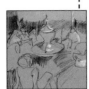

Go to a very busy place and draw a series of quick sketches, trying to capture the essence of the place. Limit your time to one, two, or three minutes maximum for each sketch, and do not complicate the technique.

SERIAL WORK

Occasionally, once you finish a sketch, you might not be completely satisfied, and you imagine changes or enhancements you would make to it. To do this, you can work with a series of drawings. The first sketch is followed by a second one that corrects or complements the first one. That is why you should sketch the model repetitively, which is a useful way to study the different frames, visual perceptions, interpretations, and style variations.

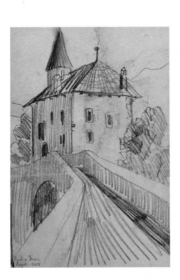

Serial work is done here by observing the model from different points of view to select the best frame.

Here, in comparison to the previous sketch, the light has been moved to alter the perspective. The tools used also have changed. This sketch has been done with a charcoal stick and a sanguine (red chalk) pencil.

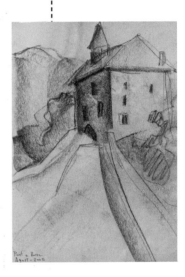

Serial work ends with a third frame of the same model. This time, the main elements are ink and a more ingenuous interpretation.

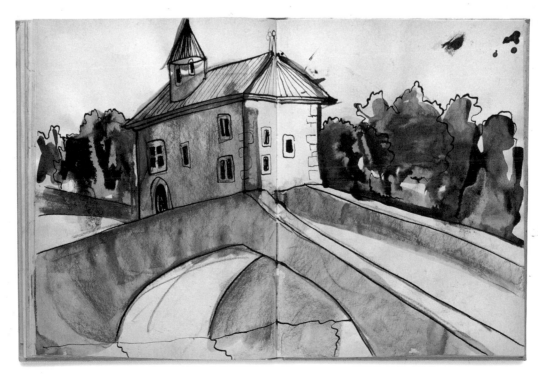

a game of
Lines
and
forms

"AN ARTIST MUST NOT PLAN HIS WORK BUT RATHER LET IT EMERGE. A SKILLED
HAND OFTEN DOES BETTER THAN THE BRAIN."
Paul Klee, Journal III, *1906.*

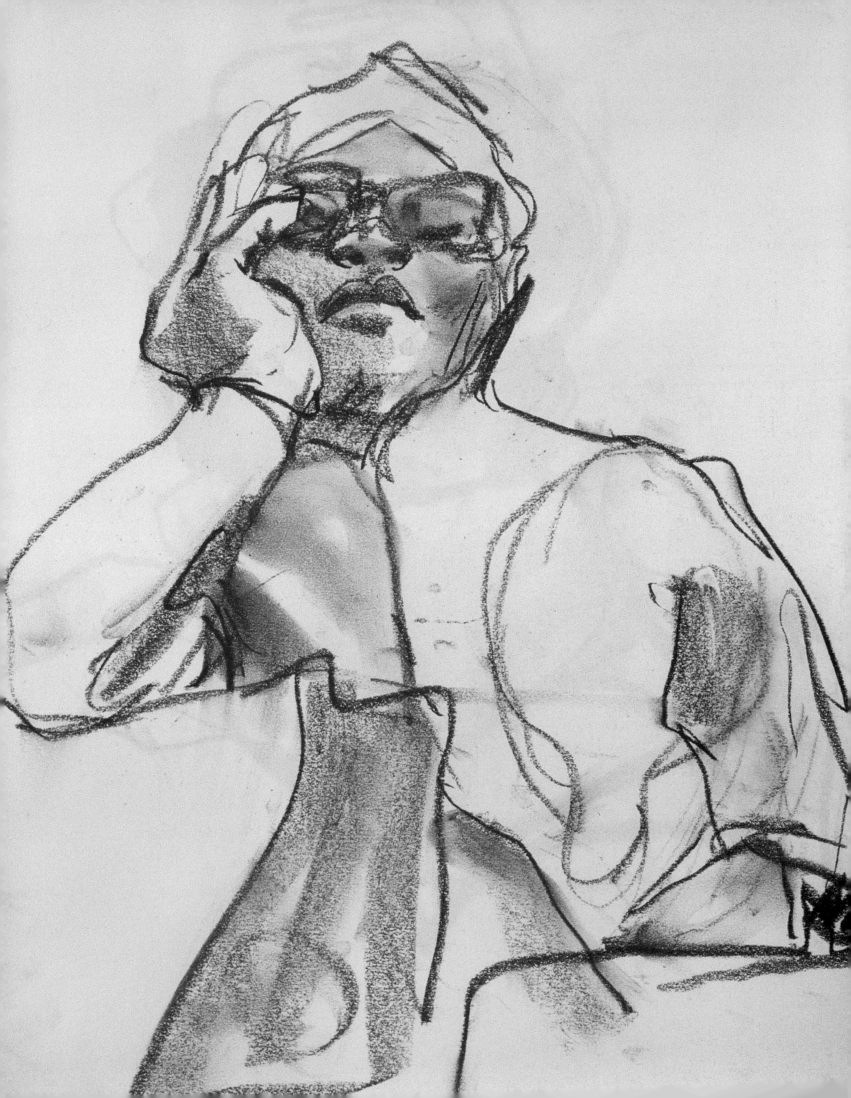

Line strategies

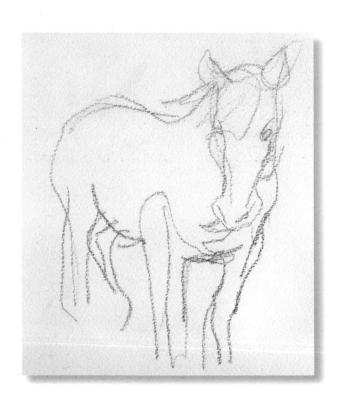

in sketching

Sketches are an excellent place to test the use of lines.

Lines are perhaps the most widely used technique in these drawings, due to this technique's speed and versatility. Nevertheless, using purely linear means is the most difficult approach to drawing. You must resolve the tones and textures of the motif without employing shadows or tone ranges; only lines can be used. The result can look wavy, superimposed, or arranged in a netlike pattern.

the role of Pencils
in sketching

many traditional tip elements such as pencils or graphite leads draw lines more easily than they do tone areas. In trained hands, lines are able to describe almost all the visual effects produced by the drawing. In this way, the role of the line varies depending on the intentions of the artist.

SOFT LEAD PENCILS

Soft pencils (4B, 6B, or 8B) turn the entire sketch into a test drawing. They do not allow you to excessively prioritize the lines. The drawing becomes a net of soft, wavy, and imprecise lines. The intense lines are achieved by pressing the tip firmly against the paper, giving a bit of disorder to the image. The gradation of these leads is excellent for quick sketches and drawings with expressive lines and tones, especially those on textured paper.

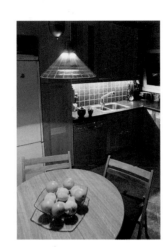

1. To sketch using graphite, first sketch the model with a soft pencil. This will allow you to find profiles and principal forms.

2. Once you have determined the position of each element, emphasize the objects by using lines to highlight those in the foreground.

3. The last phase is applying shadows. This is done by tilting the tip of the graphite lead and using just two values. You must never finish details.

1

2

3

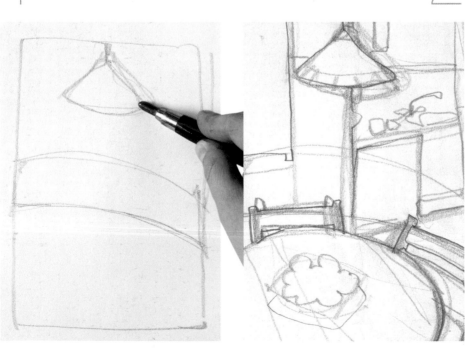

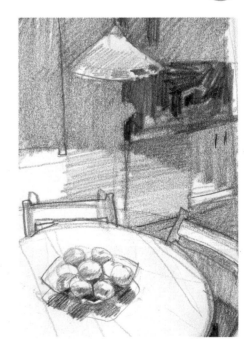

Graphite sticks allow you to quickly achieve shadows and give a very expressive touch to your sketches.

SKETCHES WITH HARD LEADS

Hard leads (HB, H, or 2H) create more grayish lines than black lines. They are appropriate for architectural sketches, urban scenes, and subjects that require more precise details. You must keep the tip very sharp to achieve a clear and incisive line; otherwise, the drawing will have a softer look.

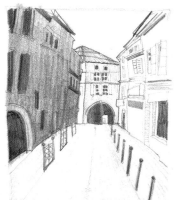

In urban scenes that require more detail and precision, you can alternate soft and hard leads

GRAPHITE LEAD

Graphite leads are the best ones to use for drawings with a lot of contrast or expressive interpretations. They allow you to work with different line intensities to achieve dark and soft shadows. Thick and clear lines attract our attention, highlighting their subject and appearing closer to you, whereas the softest lines give a feeling of distance.

Graphite leads allow you to combine fine lines with broad lines. The intensity of the shadow depends on the pressure applied with the flat stick.

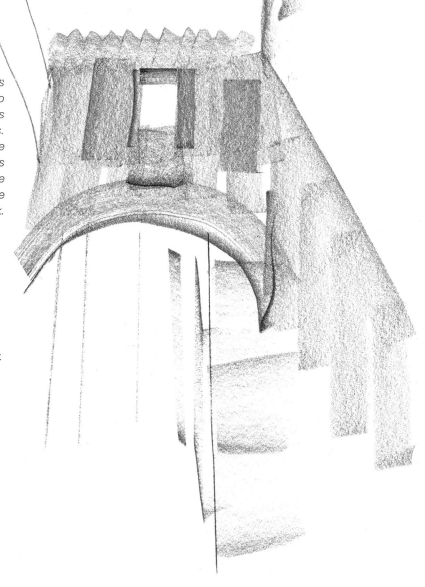

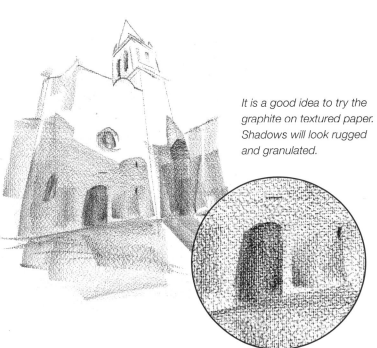

It is a good idea to try the graphite on textured paper. Shadows will look rugged and granulated.

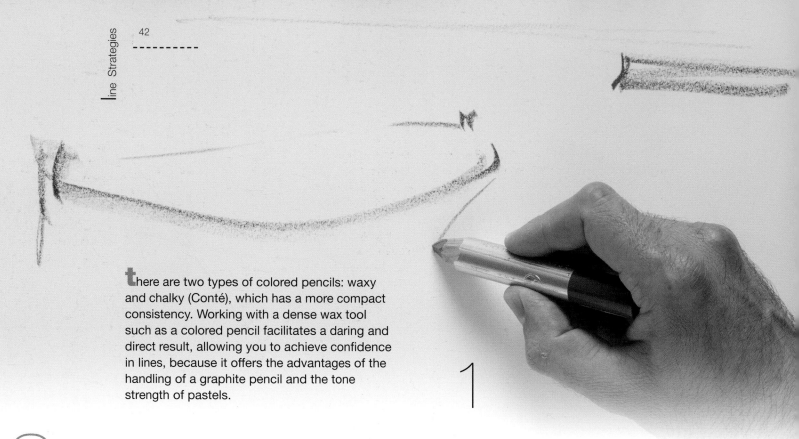

there are two types of colored pencils: waxy and chalky (Conté), which has a more compact consistency. Working with a dense wax tool such as a colored pencil facilitates a daring and direct result, allowing you to achieve confidence in lines, because it offers the advantages of the handling of a graphite pencil and the tone strength of pastels.

1

Sketches with
colored pencils or Conté pencils

THICK AND INTENSE LINES

Wax pencils are wrapped in either paper or wood. Their line is saturated, firm, and dense, and their waxy consistency does not allow for wide tone scales, so contrast in lines is their main feature. The weight and thickness of the line, its flow and experimental nature, the way it can be continuous or discontinuous, create effective visual illusions in sketches.

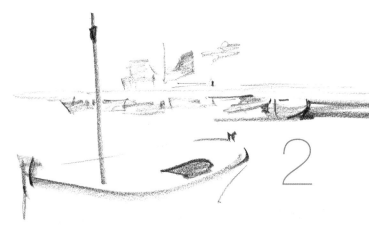

2

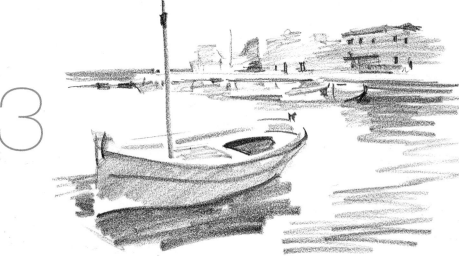

3

1. Wax pencils offer a firm line that allows for little modification. That is why sketches with this tool must be done with very soft lines.

2. Capturing the subject requires you to be both accurate and cursory. Many lines remain as hints or are interrupted.

3. Then light shadows are applied with a zigzag pattern on the water; wider ones are placed under the boat.

WAYS TO DRAW

There are two ways to draw with a colored pencils: one of them is to draw very soft lines quickly, almost without lifting the pencil off the paper. Then you can reinforce the initial soft lines with more intense and vigorous lines. The second way is freer and more informal than the first. From the get-go, the lines are spontaneous and more intense than the other method. The risk of making a mistake with this technique is bigger, but you cannot be intimidated by this possibility.

CHARCOAL PENCIL

The charcoal pencil offers a consistency similar to that of the wax pencil. These two drawing tools share the same intense lines, although charcoal pencils are less waxy than wax pencils. This makes them a very valuable tool for artists. Having a sharp lead for drawing is critical; the tip wears off very easily.

Some wax pencils do not need to be sharpened with a pencil sharpener. You can just pull the string at the side to unwrap some of the cardboard cover.

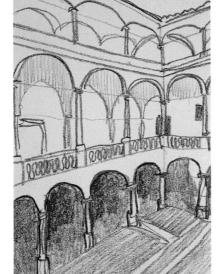

Another way to work with colored pencils is with vigorous lines, ignoring the risk of making mistakes.

Use of a wax pencil is inconvenient in that it does not allow for wide or rich tone degrees.

Conventional charcoal pencils have characteristics similar to those of graphite pencils, although they offer more tones when you are applying shadows

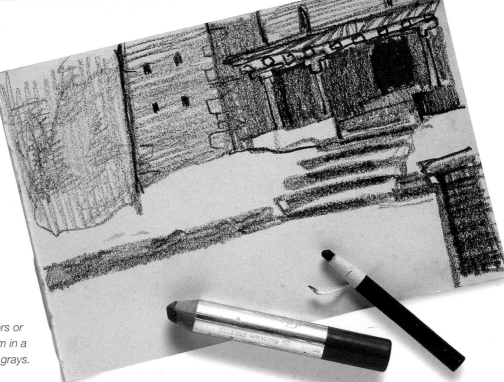

If you have pencils of different colors or hardnesses, you can combine them in a sketch to achieve a wider range of grays.

carpentry pencils,
a wide, flat tip

flat and tapered pencils, typically used for construction and carpentry work, are very popular with artists. They are very useful for sketching because of the variety of lines they produce.

THE WIDTH OF THE LINES

Carpentry pencils have a wide, flat tip that offers a thick line. If you vary the inclination and position of the tip on the paper, working with the taper, you will achieve the opposite effect, resulting in a fine line. This strong contrast, going from one type of line to another by rotating the wrist, is their main advantage. It allows you to create a linear drawing with a wavy line, with consistent thickness variations depending on the profile of the model.

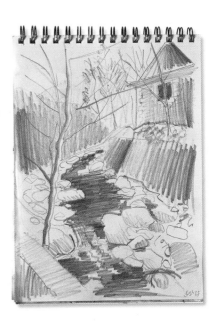

The main characteristic of the carpentry pencil is that it allows you to apply shadows very quickly.

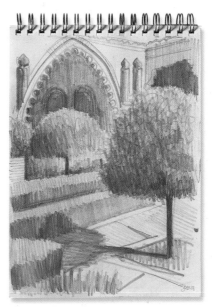

The tip is medium soft, useful for shadows.

This drawing tool is called a carpentry pencil because it is very common among carpenters. The tip of the pencil is versatile. Working with the thin part of the tip, you can achieve very fine and precise lines, whereas using the wide part of the tip, you will obtain thicker lines.

DIFFERENT LINEAR QUALITIES

The effect of a line drawn with a carpentry pencil can be very energetic: decisive, thick, and intense. Or it can be hesitant, with a soft line made by several superimposed lines. It can also be thin, clean, and precise, done with the side of the flat tip and with medium intensity. Or it can be wavy or varying in intensity, constantly changing in thickness, to give more emphasis to a profile, and then decreasing to a fine line to subtly insinuate a contour.

The versatility of the line made by the carpentry pencil makes it a critical tool for artists who draw urban scenes.

Sometimes when you begin to sketch, your determination to make it "right" affects your ability to be spontaneous. Allow yourself to treat the technical and artistic aspects of the drawing with much less respect than they deserve.

The carpentry pencil is also ideal to use for landscape sketches, because the line allows you to capture a model with a lot of expression.

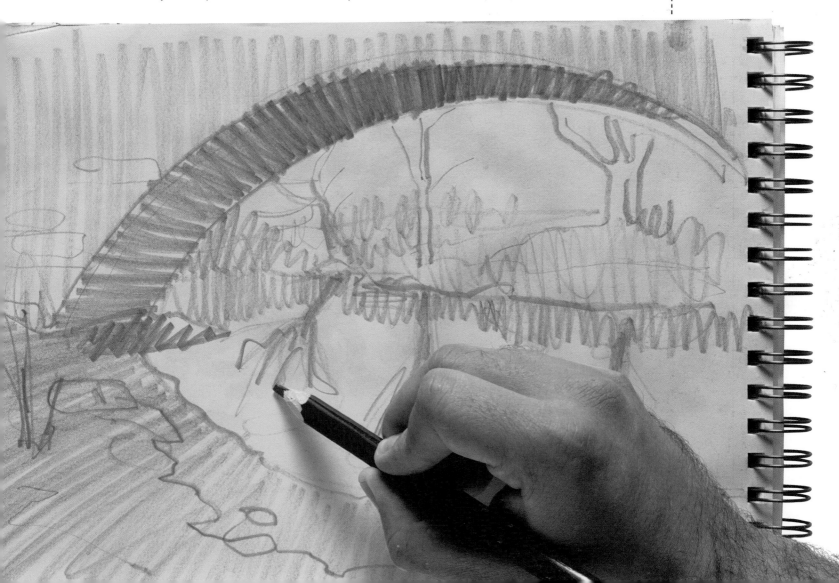

Contour
lines

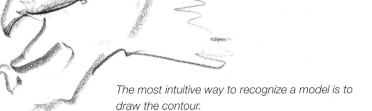

Working the contour is an excellent exercise to capture and draw, at a glance, any shape, regardless of how complex it is. For the lines of the contour to have a three-dimensional effect, you will need to vary the quality and the value of the lines. Widening the line can show shadow or proximity to the viewer; weaker lines show light or distance.

DRAWING THE CONTOUR

The basic drawing of an object can be quickly and intuitively drawn with specific attention placed on the lines of the contour. The result is an outline.
One of the most noticeable features of this technique is the way in which interruptions and variations of thickness of the line that describes the contour of the model can create the illusion of solidity and depth of form.

The most intuitive way to recognize a model is to draw the contour.

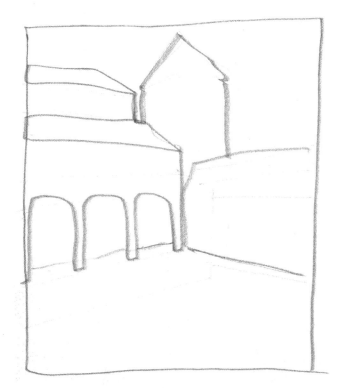

Drawing sketches in which you draw only the contour of the main lines is a good way to practice.

The study of outline is another way to approach a subject. You must prevent the textures and interior forms from disrupting your analysis of the subject.

HOW TO DRAW

You should select a model with a simple contour, such as a piece of fruit or a slice of bread. The first stage is to observe it. Then, when you begin to draw, your hand and your eyes move at the same speed; that is, at any given moment, your eyes are observing exactly the same part of the subject that is being drawn. It is useful to imagine that the tip of the pencil does not touch the paper but rather the model. You must draw the outline in a deliberate and analytical way.

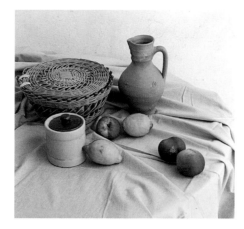

Once you master the technique, you can practice more complex techniques with interior lines.

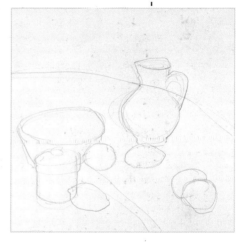

1. As you analyze the model, tentatively outline the contour of the forms.

2. The first outline is done with a light line that allows you to make corrections as you go.

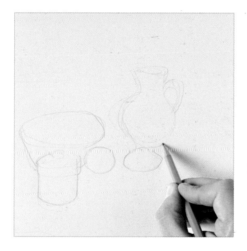

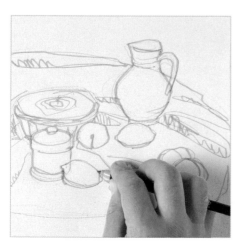

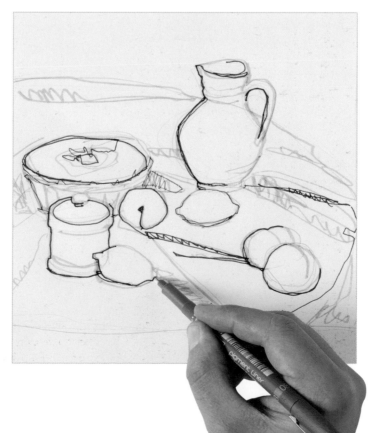

3. The contour of the objects is reinforced with more intense lines, and the first interior lines of the objects appear, depicting their texture and volume.

4. You can complete the sketch by differentiating some lines with a fine-tip black marker, passing over only some lines to give more solid lines to the sketch.

Linear drawing:
control and character

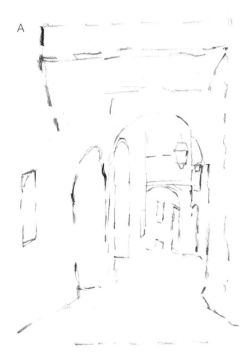

Some of the most suggestive drawings have been created with just a few lines. In a drawing based only on lines, without any pattern, the entire weight is on the evolutions and trajectories of the lines, so there must be an ancillary interest in those trajectories.

VARIETY OF LINES

There are some tricks to creating a feeling of volume and space in a linear drawing: interrupting the line when giving depth to a form; emphasizing the line when describing rounded forms; fitting the image; or working the same line over and over again to achieve a well-defined contour that arises from a network of lines.

A

B

C

A. Practice the same model with different variations of lines to understand how it affects the final result. Begin with soft, unstable, and doubtful lines.

B. Continue with a sketch in which the firm, thick lines that give more solidity to the structure are evident.

C. Repeat the process, now drawing with soft, multiple, superimposed lines. Compare the three drawings and check how the line is able to convey fragility, firmness, vibration, and an out-of-focus effect.

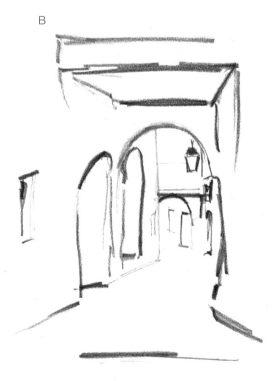

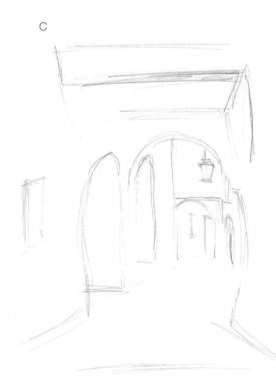

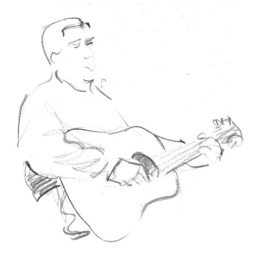

Wary lines vary in thickness and intensity throughout, to add information on the volume of the model they represent.

You should not show too many lines in a complete sketch. This will also prevent the paper's surface from getting greasy and dirty from fingerprints or friction from your hand.

WAVY LINES

Wavy lines represent very subtle changes of width and intensity, with the purpose of showing the fragility or force of the shapes they describe. The line is not only in the borders, but crosses forms, indicating where the surface of the object is closer or farther away from the viewer, where it is curved and where it is flat, following a tactile sense.

REAFFIRMING THE LINES

Simplicity is often the key to a successful line drawing. It is important to avoid excessive elaboration of the image. When the sketch is completed, the line is reaffirmed with a much more intense line. It is easier to reinforce the lines on a previous sketch.

A not-too-firm line, interrupted, conveys fragility and a lack of stability to the drawing.

The shaky and superimposed lines on the previous page are easily adaptable to a sketch done with markers.

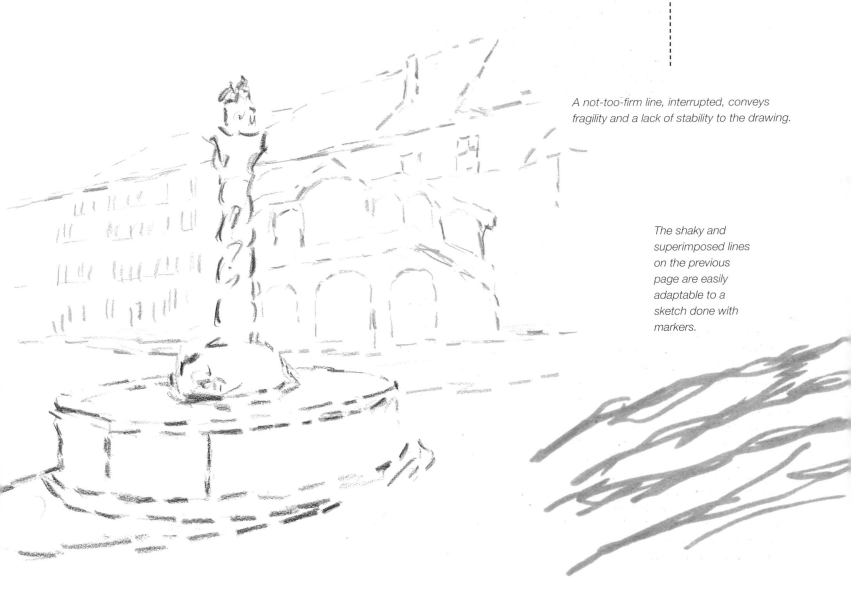

It is very common when sketching with a ballpoint pen or a very sharp pencil to sketch with a line that is even in thickness throughout the sketch and continuous. This line looks like an endless thread that starts weaving in the drawing to describe the contour, volume, and light and shadow qualities of the model.

thread Sketch with continuous lines

A CONTINUOUS THREAD

A practical exercise for drawing quickly and easily is to try to complete the sketch with only one line, without lifting the pencil off the paper, as if you are drawing the profile with an endless wire. The sketch must be quick and the line continuous, without interruptions, smearing, superimposing, or shaking. Gradually, from a mess of lines a shape arises that resembles the model.

1. Analyze the process of drawing a thread sketch. With a continuous line, draw the pillar and shade the interior part of the scene.

2. The continuous line continues and reaches the top of the paper to detail the structure. This method does not allow for the possibility of correction.

3. If you like, you can come back on the same line to go in a different direction. Leave some shadow effects for the end.

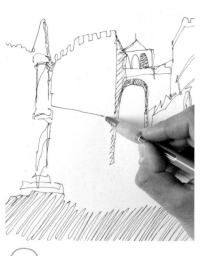

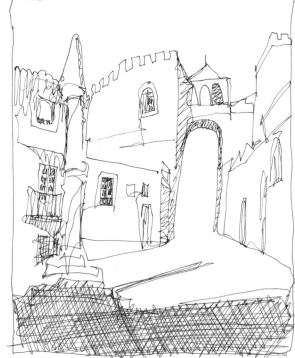

GEODESIC LINES

This thread sketch is reminiscent of a topography map, as if the artist was drawing geodesic lines. Thinking of this concept will help you learn to model the interior volume of the objects in your sketches using this technique. This sample shows a wide variety of interior contours, a map that reveals the topographical qualities and its different modulations, especially the tensions, the features of the form, and the inflections of volume.

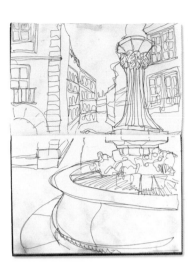

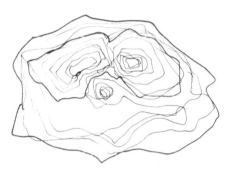

Sketch done with a ballpoint. It is convenient to practice with ballpoints, because they are often the tools that we have available.

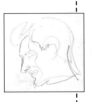

In thread sketching, it is common to find a lack of proportion, especially when figures are being drawn.

Geodesic lines represent mountain levels in topography maps.

Geodesic drawing is a variety of thread drawing, formed by numerous juxtaposed concentric lines.

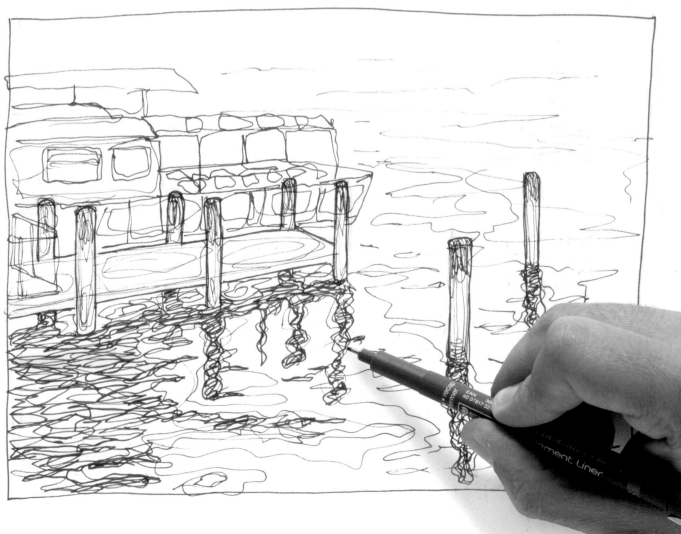

Shadows and textures

the study of textures is a fascinating subject in itself. You could easily fill several notebooks with just textures or shadows treated with different techniques.

SHADOWS

When you work with pencils or linear drawings, shadows are applied with nets, or cross-hatching. The level of density of the shadow is determined by the number of lines drawn in a specific space. It depends on the style and quickness with which the sketch is executed, because the lines can be very defined and thorough or just simple, vigorous lines. You can draw all the lines in one direction or draw different layers at different angles.

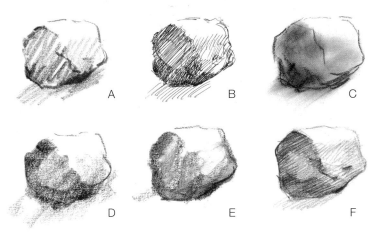

Example of different quick shadows that are used frequently in sketches: stripe pattern (A), typical net pattern (B), blending (C), "dragging" (D), "dragging" with a slight modeling (E), and tone ranges with a net pattern (F).

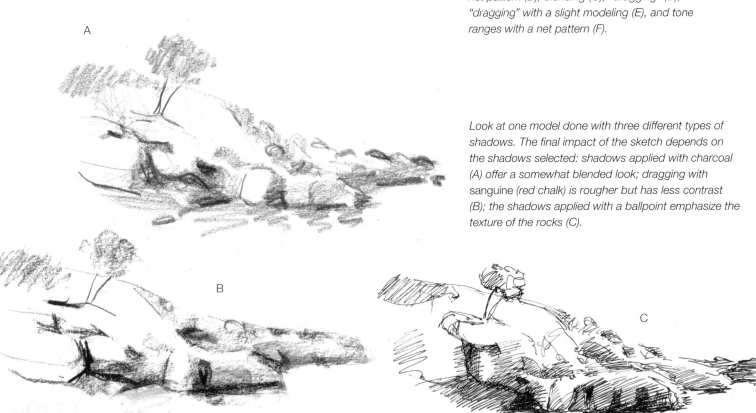

Look at one model done with three different types of shadows. The final impact of the sketch depends on the shadows selected: shadows applied with charcoal (A) offer a somewhat blended look; dragging with sanguine (red chalk) is rougher but has less contrast (B); the shadows applied with a ballpoint emphasize the texture of the rocks (C).

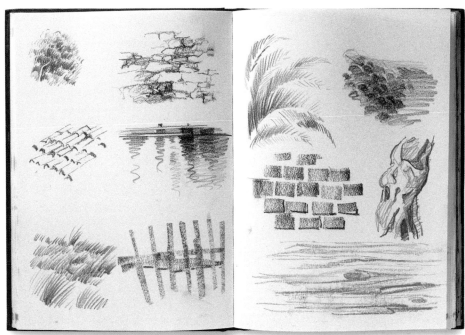

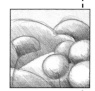

Shadows always try to represent the "roundness" of the objects, since all nature is formed by round shapes, spherical volumes, cone volumes, or cylindrical volumes.

When you are drawing outdoors, it is important to select details of surfaces that allow you to study textures and learn to create them with different techniques.

PEN EFFECT

The pen effect is the most common technique used to apply shadows in sketching. It consists of parallel lines that are very close together to give an effect of tone. The lines can be thick or thin ones, although the width and weight of the line and the density of the pen effect can be varied to create a range of tones. It is possible to draw the lines meticulously or to draw them freehand and informally.

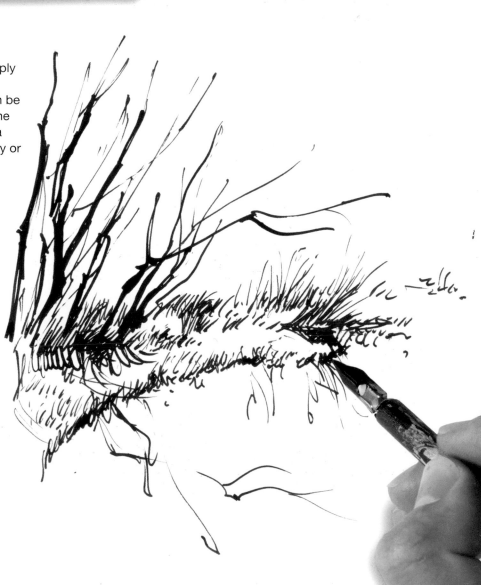

Working with ink and a stick, you can create a broken and frayed line that very accurately represents the texture of wood.

A pen effect or series of fine lines drawn very close together is very useful when sketching vegetation. This effect increases if you use the pen effect with an ink pen.

researching the Variety of structures and lines

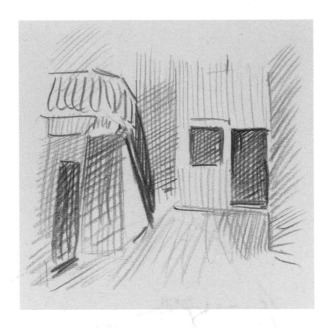

Sketch with a parallel diagonal structure and a structure at an angle. By using just a few super-imposed lines you can intensify the tones.

the first step that any amateur artist must take is to research the different types of lines to become familiar with them before starting to draw and to see how they impact his or her sketches.

CROSS-HATCHING

Cross-hatching is a type of shadow that gives an interesting textured effect to the drawing. This technique combines two or more groups of parallel lines crossing at a certain angle. The lines do not need to be straight; you can cross curves, dotted lines, or zigzag lines with color ink and markers. You can apply this technique with any drawing tool.

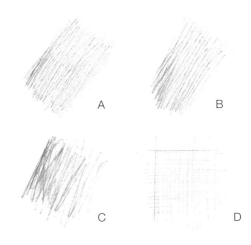

A B

C D

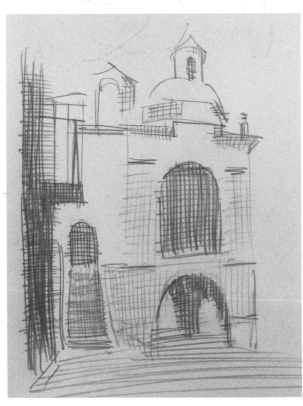

The structure in a cross hatching is also very useful for applying shadows in some areas of the sketch. It is a quick technique and does not require much work.

A. *Typical parallel diagonal structure, very quick and easy to do.*
B. *Structure crossed at an angle. This is the best technique for studio sketches.*
C. *Structure crossed at different angles. This is the best option when working outdoors.*
D. *Structure crossed in a cross pattern. This is the least aesthetically appealing of all, but it is very practical for intensifying the tones of sketches.*

DIRECTION OF THE LINE

Apart from the intensity and thickness of the line, its direction is also important. It must depict as much as possible the volume and texture of each element. In other words, the orientation of the lines is useful because it expresses not only the texture or the shadow effect of the object but also, in part, its volume.

LETTING SHADOWS RUN WILD

The challenge of researching textures is the ability of the tool used to create lines that represent the variations and complexities of the objects in a scene. Let the tool you use and your hand move freely; forget all the shadowing, stripe patterns, lines, dragging, and "pushing" techniques; and make the pencil, pen, or brush roll on the paper; draw stains, dots, little dots, and blobs and lines of tone or color.

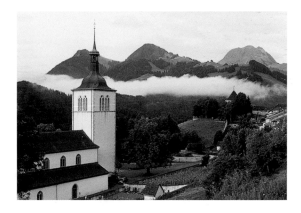

Find surfaces with a defined texture that you can easily study in 15-minute sessions. The textures of the branches and foliage of trees are so complex that each artist finds a different solution to depict them.

A

Three versions of the same model with different line directions: a parallel vertical line that highlights the verticality and force of the model (A), structures that merge in a spot on the horizon, reinforcing the depth of the landscape (B), and circular lines that emphasize the thickness and roundness of the objects (C).

B

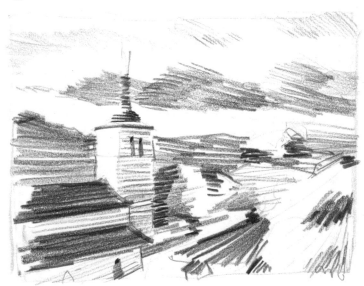

C

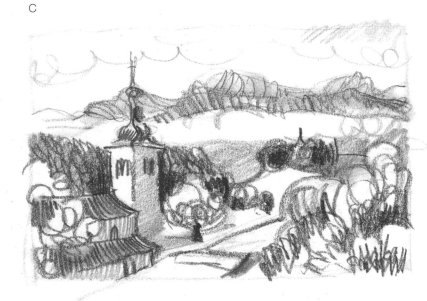

There is no rule restricting you to use of just one tool or technique per sketch. One way to achieve more flowing and airy sketches is to combine lines and ink washes. This technique consists of drawing with an ink pen, marker, or watercolor pencil, letting it dry, and then applying light ink washes to the drawing.

Watering the lines,
diluting the drawing

EXPANDING THE LINES

A traditional combination that many contemporary artists continue to use is watering the lines. Lines can be drawn with watercolor graphite, an ink pen, or a marker. Over the dry lines of pencil or marker, or when the ink lines are still moist, you can pass a brush wet with water to blend the lines, mitigating the clear lines by reducing their intensity and expanding them. With this technique, you have all the flexibility and expressive potential that the lines can offer and the ease to produce tone or light and shadow, or to color quickly with the ink wash.

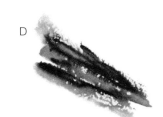

A
B
C
D

Ink washes are applied on lines to expand them and to create tone effects. These are four ways to water the line of a marker: the first two are created by drawing the lines on wet paper (A and B), and the other two are formed by diluting the line with the brush (C and D).

Drawings done with a marker make it very easy to water the lines. The ink dissolves quickly and gives areas of tone that are very generous and dark.

This sketch combines lines drawn with a marker and black pen ink. The background has been watered down to soften the structural lines of the buildings.

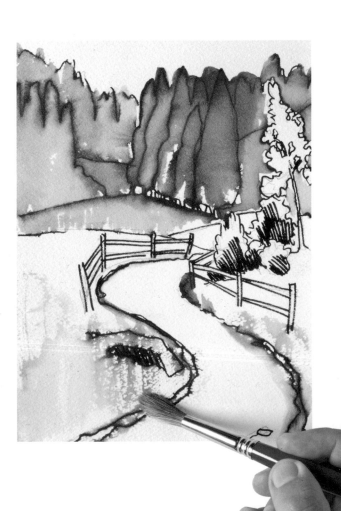

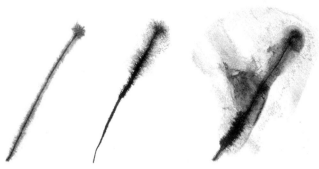

You can also expand the lines if you work with a pen with China ink on wet paper. The degree of expansion depends on the amount of water on the paper. These are three examples that show the pen on paper with less water (far left) to more water.

Dilutions can only be done in small areas at a time, and it is not advisable to apply too much water to spread the color. You must work in specific areas, blending, merging, and diluting the line.

UNITY BETWEEN BOTH TOOLS

It is difficult to achieve unity between both tools; in other words, the drawing looks like the tone has been added to the line as a later idea. To avoid this, you must use both tools simultaneously, working the line and the water tone at the same time, so that the result looks like one effort.

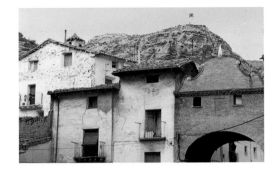

1. In this exercise, analyze how to water down the line that has been created by a ballpoint. First draw the model with firm lines, without shadows or structures.

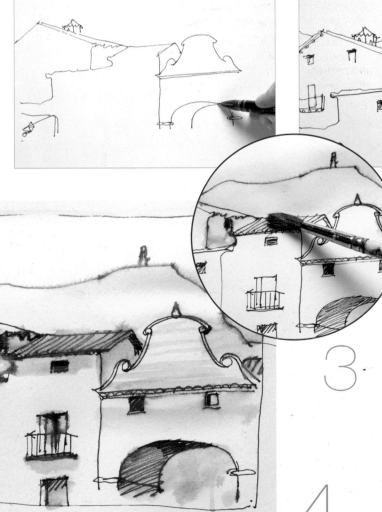

2. Add the details of the shingles and darken the windows of the buildings with lines that are very close together.

3. With a medium-round paintbrush that is dampened with water, softly caress the lines of the background mountain and the upper profile of the roofs.

4. When you add the ink wash, the blue ink dissolves and spreads in soft tonal areas on both sides of the lines.

the same Model
developed with different drawing instructions

The line-drawing techniques are directly related to the tool used. The process varies depending on the materials and the technique used. Each artist develops his or her own preferences regarding the best techniques. Some prefer fine and precise lines; others prefer wide, informal lines that are quickly generated.

DIFFERENT TREATMENTS

Each linear treatment offers a different finish and gives a specific character to sketches. Look at some examples; compare different linear techniques using the same model as a reference.

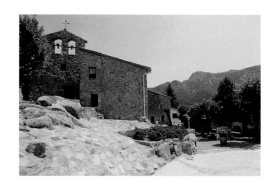

1

2

3

1. Tackle this version with a graphite lead. In your initial sketch, emphasize the building with thick lines.

2. Draw the lines by scribbling, pressing the lead harder on the paper. With a stripe pattern, apply short shadows.

3. The work with the graphite lead is more spontaneous and expressive than the first version with the fine line, more delicate and softer.

1

2

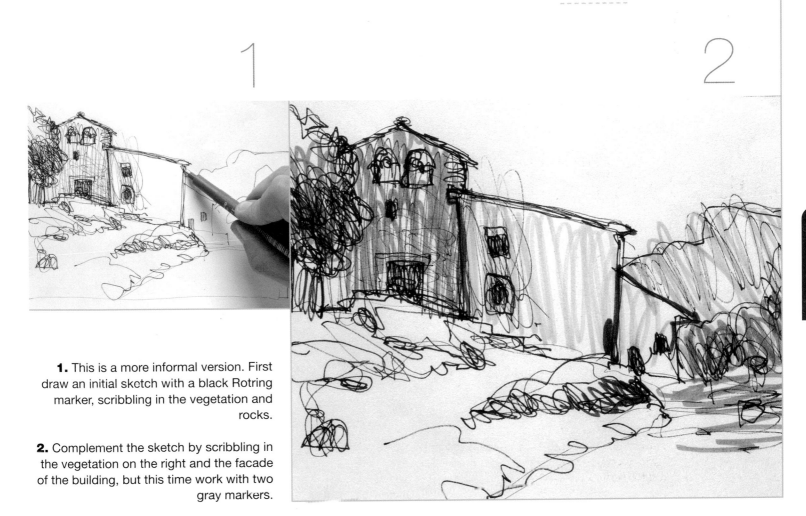

1. This is a more informal version. First draw an initial sketch with a black Rotring marker, scribbling in the vegetation and rocks.

2. Complement the sketch by scribbling in the vegetation on the right and the facade of the building, but this time work with two gray markers.

1

2

3

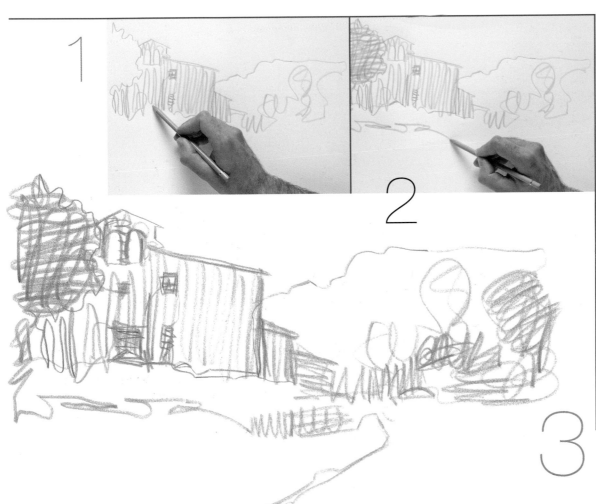

1. The last sketch uses a gray pencil. Work in a threaded way, with one line, without lifting the pencil from the paper.

2. Draw one line as if it were a long wire outlining all the forms.

3. The linear sketch is not limited to the profile of the elements. You can create some shadows with stripes in a zigzag pattern.

Washes, shading, and

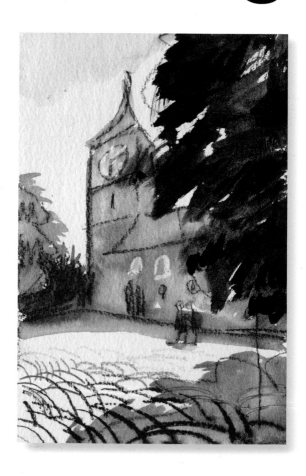

MERCEDES GASPAR. A TOWN SQUARE IN ZURICH, 2005. INK WASH AND BLACK PENCIL.

value guidelines

When planning a sketch, picture it as a set of washes

with different degress of intensity, depending on how the light affects the different areas. Establishing value guidelines is a very important part of the process. Line drawing is a quick and appealing way of working, but its possibilities as a technique for creating graphical representations are limited, especially when you need to create tones.

Washes and appropriate value will give more body, volume, and depth to your sketch.

Stripes, a common technique in sketches

a very common technique in sketching is to use the same lines to draw and to apply shadows. You may often work with stripes to quickly cover a shaded area. This technique is very common when you don't have much time to draw, when you are trying to achieve an expressive and imprecise effect, or when the model is moving.

IMPRECISE LINES

Typically, a stripe pattern is created by drawing imprecise parallel lines, usually done energetically on some areas of the drawing. It is not intended to create an elaborate shadow, but rather to show quickly and graphically the location of the shadows in a sketch. This information is very useful for drawing more elaborate sketches later on in the tranquility of your artist's studio.

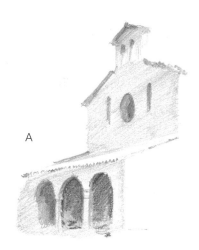

A

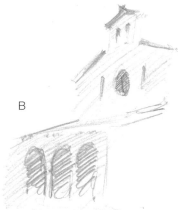

B

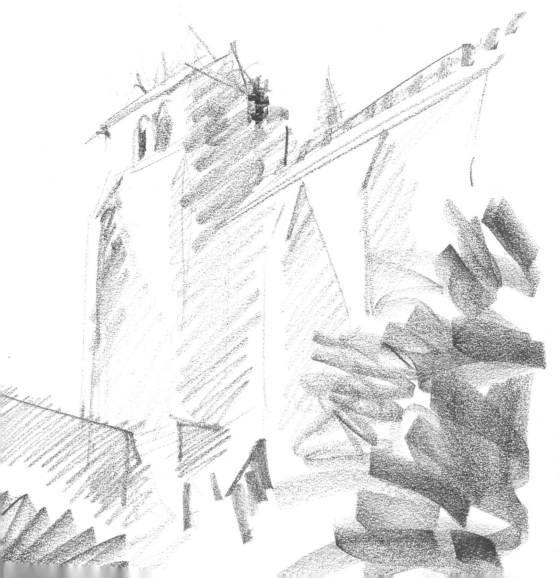

Comparing these two drawings, you can see the difference between a traditional shadow effect (A), which is done with controlled and even tones, and a stripe-pattern shadow effect (B), which is achieved with lines that stand out and have been drawn much more quickly

The stripe pattern covers a shaded area very quickly. This technique has a direct impact on the precision of the sketch.

DRAWING OUTSIDE THE LINES

When applying shadows using a stripe-pattern technique, hand movement and speed are the most important things. This results in a lack of precision, going outside the lines that define shapes and not taking into consideration the profile of the objects.

DIRECTION OF THE STRIPE PATTERN

If you do not have much time, all the stripe patterns in your drawing usually have the same direction. However, each stripe pattern should have the correct direction. The direction of the stripes is not random. It must follow a certain orientation based on the volume of the model and the features of the object's shadow. The different ways to apply a stripe pattern, when the artist is skilled in this technique, are a useful way to highlight contrasts, differentiate planes, and depict an object's volume.

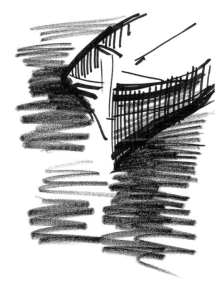

Rhythm is essential to achieving lines. It plays the same role in drawing that it does in music. It can be achieved with an expressive repetition of lines.

Drawing a stripe pattern hurriedly often means going outside the lines that define the objects' shapes.

A stripe pattern, when intense and thick, can become the main attraction of the drawing.

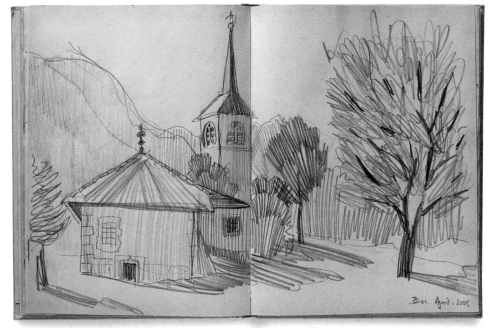

A stripe pattern is a natural sketching technique that allows you to quickly apply shadows. To better delineate the different planes, the stripe pattern should change directions

washes, drops, and runs of ink

Ink wash, when worked softly, is a good technique for applying shadows. For example, it can be combined with lines to give texture to vegetation

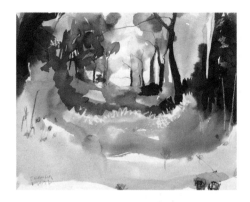

a good way to begin a tonal sketch is to build a model with stains, shadows, or ink wash, without a preparatory line sketch and in a rather spontaneous and uncontrolled way. Stain drawings can be done with dry or wet techniques, as long as these materials are used decisively and with energy.

SKETCHING WITH SHADOWS

In those cases where a model is strongly lit, another very effective way to draw is to clearly establish light and shadow areas with a quick dappling technique, using the flat side of a piece of charcoal, graphite, or an ink wash. This drawing completely omits details, including ranges of mid-gray tones. This is a first reading of the model. The edges of the shadows are good reference points for completing the drawing with lines superimposed on the washes.

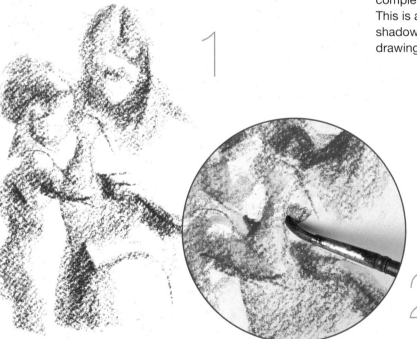

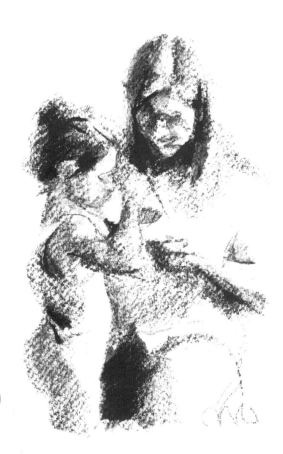

1. Through a simple technique, convert these shadows into washes. Ignoring the lines, first shade the area with a stick of sanguine.

2. Using a wet brush, dilute the shadows into dark stains that are more or less alike.

3. To achieve variety in the drawing, do not dilute all of the shadows with water. Leave some untouched to preserve the paper's grainy quality.

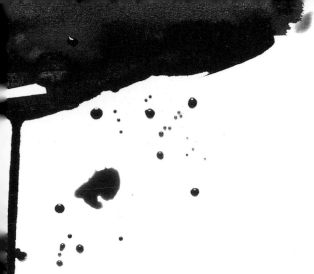

A good way to introduce a random component in sketches is to spread ink stains in the notebook, close it, and then reopen it to see how the ink wash turned out. Then you can work on the resulting forms.

INK WASH, THE PREFERRED METHOD

Ink stains are the most commonly used method to improve and highlight sketches. This is because of their quick application, the rich tonal range that can be achieved, and especially their great expressivity and spontaneity. The ink can drip onto the paper from a brush, or the lines of ink can randomly spread on a moist piece of paper, providing an uncontrolled effect that adds more interest to the sketch.

WATERCOLOR GRAPHITE, THE ALTERNATIVE

Watercolor graphite is water soluble and gives effects similar to those of ink wash. It is recommended that the drawing be started with quite a few shadows, and then the wet brush should be applied wherever specific light and shadow effects are needed.

When shadows are created with a pencil, their limits, the tone, and the definitive shape are more controllable than when they are created with an ink wash.

1. In sketches done with watercolor graphite, draw and apply shadows in a conventional way. Once the sketch is finished, accent some shadows by passing a wet brush on top.

2. When wet, the soft graphite shadows darken and become more compact.

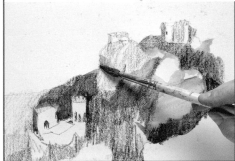
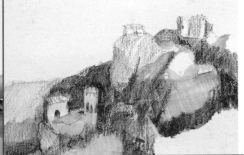

We are attracted to sketches like this one, in which the drops and quick, informal movements with the brush are the key to expression.

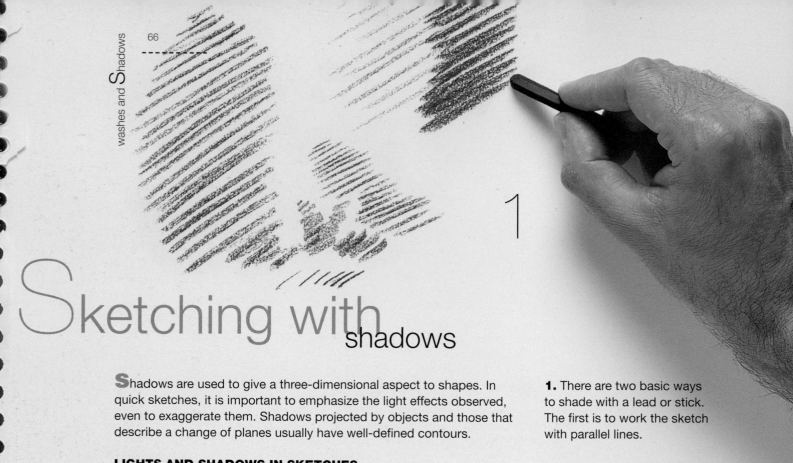

Sketching with shadows

Shadows are used to give a three-dimensional aspect to shapes. In quick sketches, it is important to emphasize the light effects observed, even to exaggerate them. Shadows projected by objects and those that describe a change of planes usually have well-defined contours.

LIGHTS AND SHADOWS IN SKETCHES

Light reveals the shape, the structure, the color, and the texture of the surface. In sketches, when you try to respond immediately to certain visual impressions, interpretation of the image is limited due to the restrictions of the materials used. In these cases, the most effective procedure is to concentrate on highly contrasting light effects.

1

1. There are two basic ways to shade with a lead or stick. The first is to work the sketch with parallel lines.

3

2. All groups of lines are diagonal and follow the same direction. As you add new lines, the model starts to take shape.

3. Blend some shadows with your fingers and alternate the pressure in others to achieve tonal variations.

2

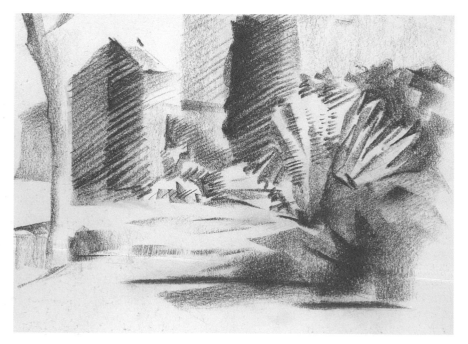

THE IMPORTANCE OF CONTRASTS

Contrasts are critical when working with shadows, because the differences in intensity between values help depict the form and distance of each element that makes up the model.

A sketch with shadows is created by emphasizing the most important features of the motif, using well-defined contrasts.

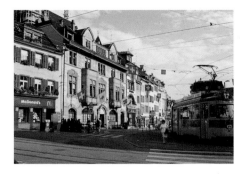

If the contours that define the boundaries between light and shadow on the different planes are clearly sketched, the shadows will be very easy to apply.

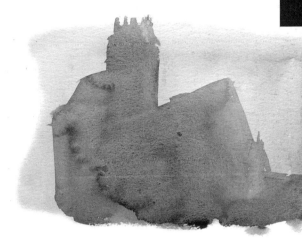

Notice how the shadow of the building is the focal point of this sketch.

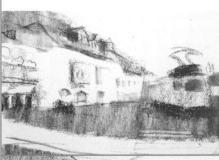

1. The basis of any shadow is contrast, because plane changes are shown with tone modifications. In the previous approach, using charcoal, this distinction is already clear.

2. By dragging the charcoal on the paper, you can contrast each zone even more to make it stand out.

3. In the last stage of the sketch, insinuate some shapes with lines and intensify the black lines with the tip of the charcoal.

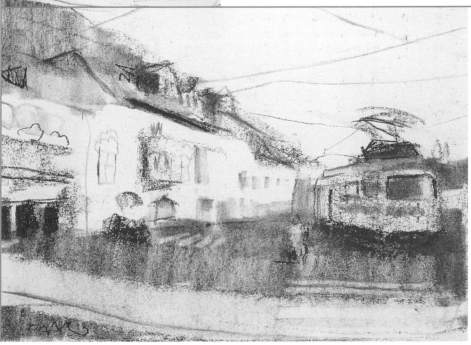

Using
tones

1

Shadows applied by using tone differences give a different degree of light to each area of the composition. This style of working promotes clarity of the shading process in sketches. However, it also subtracts definition from the drawing.

BLOCKS OF SHADOWS

Blocks of shadows blend the shaded areas in one even tone, usually a dark gray or black. To achieve this effect, draw shadows like dark color blocks, and be sure to clearly differentiate intermediate tones. To put these shadows into practice, first draw a linear outline of the model. Then, taking into account the source of light, use a dark gray for the areas in shadow. This method is very commonly used when sketches are done with markers or ink wash.

1. Using shadowed blocks with a blue marker, start by drawing the model with lines. The idea is to create an outline.

2

3

2. The shadows come right after the drawing. Begin at the top, doing sets of very compact lines to achieve the effect of a shadow block.

3. When you darken the background shadow, you are drawing by contrast the columns and the arch and the pulley of the well.

4. Once you have finished applying the shadows, the sketch will show some strong light and shadow contrasts. The blocks of shadows are even and do not have tonal nuances.

4

SELECTING TONES

When applying shadows using two or three shades of one color, you have to use a selection process. First, you need to decide to which areas of the drawing you will apply each tone, for example, which ones will be black, which will be medium gray, and which ones light gray. The fourth tone will be the color of the paper

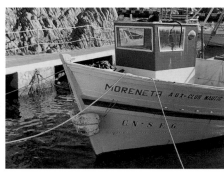

1. Start by applying even shadows with very soft tones using graphite. This is a very structured and geometric approach.

2. Each new tone addition is darker than the previous one. You need to gradually darken the sketch. The focal point is the medium-gray tones.

3. Once the sketch is finished, alternate shadows in three different intensities of gray (four, if you include the color of the paper).

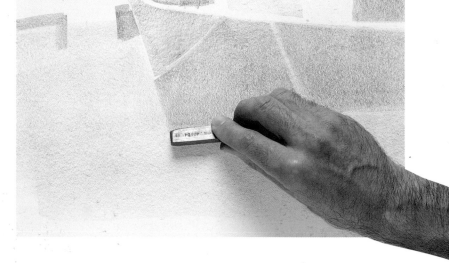

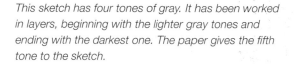

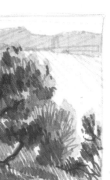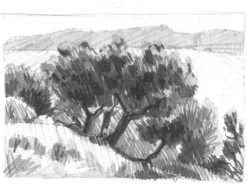

This sketch has four tones of gray. It has been worked in layers, beginning with the lighter gray tones and ending with the darkest one. The paper gives the fifth tone to the sketch.

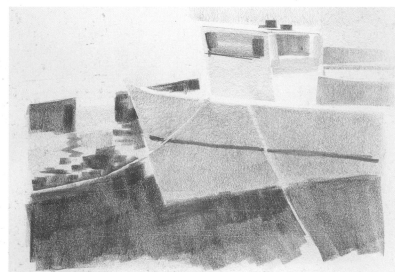

The importance of tone ranges

tone ranges are a soft transition from a light tone to a dark tone or vice versa. The purpose is to achieve a gradual order for all tones of a color range, without tone gaps. The range values are the conventional method to describe the form and the volume in a sketch, and the quality of the effect depends on the tone range used.

REALISTIC LIGHT

Whenever you want a compact tone, you need to apply shadows using tone ranges. This technique gives not only a general harmony to the drawing but also a convincing feeling of light. When you sketch, tone ranges are done very quickly, with the tip of the pencil tilted.

1

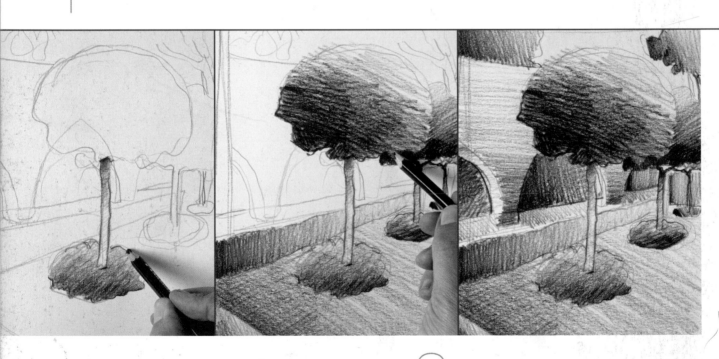

3

2

Creating tone ranges with pencils or sticks is easy. However, if you work with markers or pens, it is more complicated. In these cases, the tone range does not depend on the pressure but on how close together the lines are.

1. Apply tone ranges on sketches even if they look forced. Use tone ranges for the tree trunk and the top of the plants.

2. Work the surface of the ground, the base of the stone wall, and the tree foliage with new tone ranges. Although in the model these zones have even shadows, you have to translate them into tone ranges.

3. After applying the tone ranges in all areas of the drawing, you will have a sketch with an interesting volume effect, even if the light and shadow areas are not faithful to the model.

Tone ranges are achieved by softly caressing the paper with the drawing tool. Begin with an even pressure and a line in a zigzag pattern, and increase or diminish the pressure until you achieve a range of gray tones.

VOLUME EFFECTS

Tone ranges help give volume to the model. This is because objects under light offer different degrees of shadow on their surfaces, and you must apply tone ranges to appreciate the gradual effect of darkening shadows. Tone ranges are also an excellent technique to show distance, the depth of a landscape or scene.

WHAT ABOUT MODELING?

Due to their immediateness and quick development, sketches are not a good basis for deep modeling studies, because this technique requires very elaborate shadows and soft tone transitions that are achieved with a slight blending effect. Modeling is a soft and gradual process, avoiding the presence of pencil lines, in contrast to the quick and spontaneous nature of sketches.

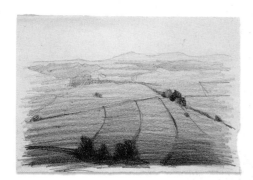

Tone ranges help show distances in a landscape, with darker tones for areas in the foreground and lighter tones for the background.

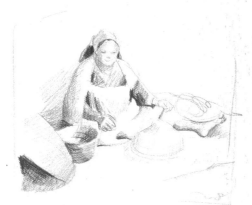

Female figure shaded only with tone ranges. In this case, the tone ranges are less forced, and shorter, and transmit the volume of the forms with more credibility.

In sketches, modeling is not commonly used to achieve blended effects or to create tone ranges in shadows.

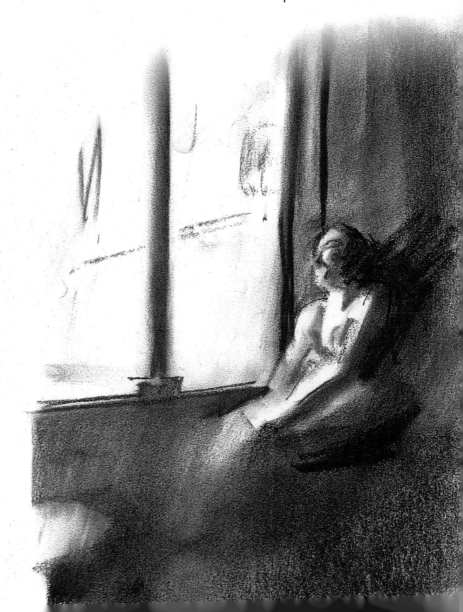

an Out-of-focus sketch:
blending and fading effects

blending is the usual method used in charcoal and graphite drawings. With this drawing technique, profiles appear out of focus and an effect of lights and shadows is introduced that is very appropriate for subjects where light fades, such as foggy landscapes or intangible models.

ELIMINATING CONTOURS
Blending creates the effect of harmony. Values merge and light and shadows alternate evenly and flowingly. The integrity of the contours is ignored. Shadows are not enclosed by a clear line. One shadow leads to another as if they were all immersed in one light fluid.

In sketches, blending is not precise, but rather general over the entire surface of the drawing. The fading tones are achieved by rubbing with the fingers so that foreground and background merge.

1. To practice a fading technique, begin sketching using a compressed charcoal pencil. Work the shadows by creating sharp contrasts.

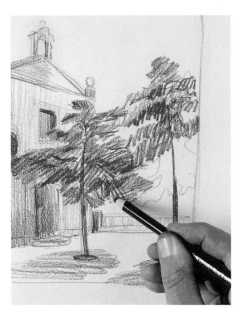

2. Once the drawing is finished, rub the entire surface with your fingers to blend the lines. The pigment spreads and covers the entire paper.

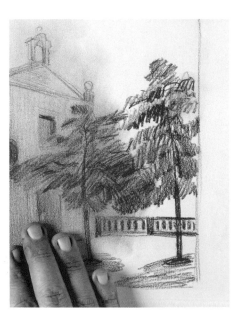

3. Contrasts are reduced and lines almost disappear. You can then make the sky lighter by using an eraser.

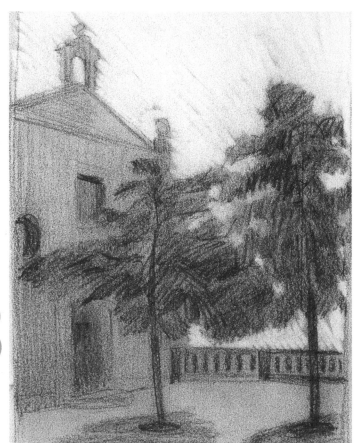

USING A BLENDING STUMP

Blending stumps are paper cylinders used to merge lines. They are interesting drawing tools. When the tip is covered in pigment, it can be used for drawing. Using the tip of a blending stump, you will achieve clear lines; tilting the tip will allow you to apply wide shadows. This technique creates very soft and evanescent sketches.

It may be useful to alternate between a blending stump and an eraser to bring out the whiteness of the paper and create luster.

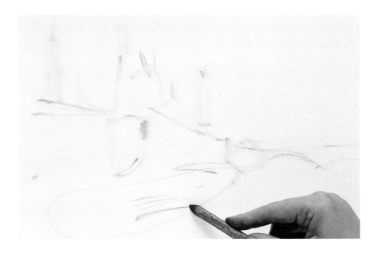

1. Using a blending stump stained with charcoal, begin to sketch the main lines in the model. These lines are soft and barely visible.

2. With more charcoal powder on the blending stump, apply the shadows to the drawing. Work with the tip tilted and even with the entire width of the blending stump (in wide areas).

3. Then, highlight contrasts and draw a few lines. Charcoal sketches are normally very gray and have soft and imprecise contours.

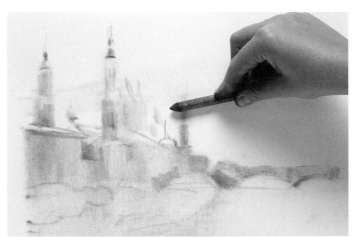

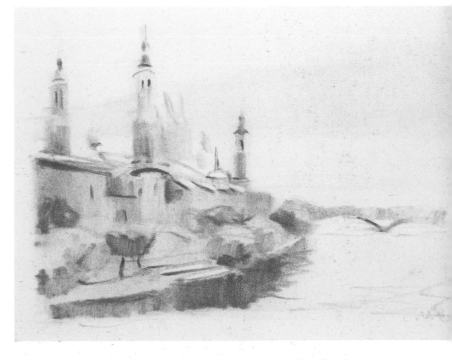

Shadow techniques

there are many ways of applying shadows to sketches, although some techniques are better than others. Let's review some of the techniques mentioned in previous chapters and explain some new ones.

The best way to know which one suits your interests and style is to try them all.

PRACTICING SHADOW TECHNIQUES

There is no better way to verify what you have learned in previous chapters than by putting the techniques into practice. From one model you will create three different sketches, each one with a different drawing tool and a different shadow technique. The variation of these factors impacts the interpretation and the degree of realism shown in the final drawing.

1

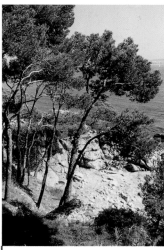

1. In the first variation, the focus is on the charcoal pencil. Draw the subject with a soft line.

2. Draw the lines in a zigzag pattern on the vegetation. As you apply a group of new lines, you can blend them with your fingers.

2

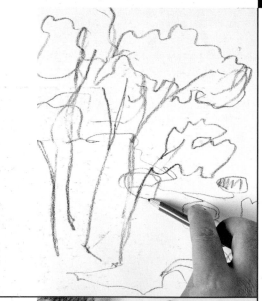

3. The finished sketch shows a very convincing tone treatment. The blending effect is critical to create soft grays.

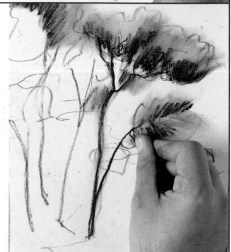

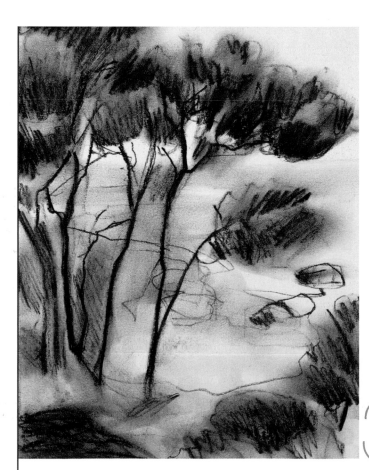

3

1. The second treatment requires a linear treatment done with liquid ink rather than with an ballpoint pen. The line is scribbled and does not follow the actual contour of the model.

2. As the drawing progresses and before you finish it, water down the lines with a wet paintbrush.

3. After you alternate lines with the ink wash, the sketch offers an effect that reminds us of watercolors.

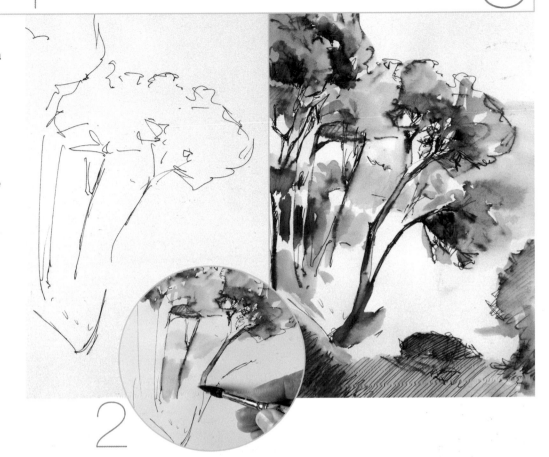

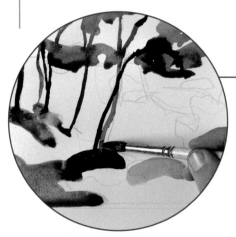

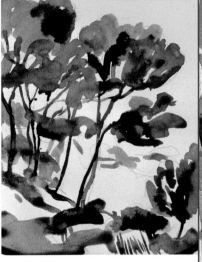

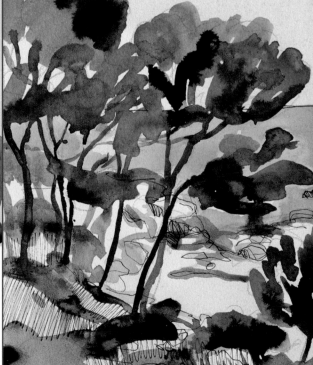

1. For the third variation, finish the sketch by practicing ink staining. Paint the top of the trees with a reddish ink. With the paper still moist, apply black stains and project the tree trunks with just one line.

2. Work the foreground the same way, letting the red and black spots blend randomly.

3. Complete the ink wash by adding fine lines to represent the rocks (done with a fine-tip marker). Draw the water with a gray transparent ink wash.

Mate-rials, resources, and graphic styles

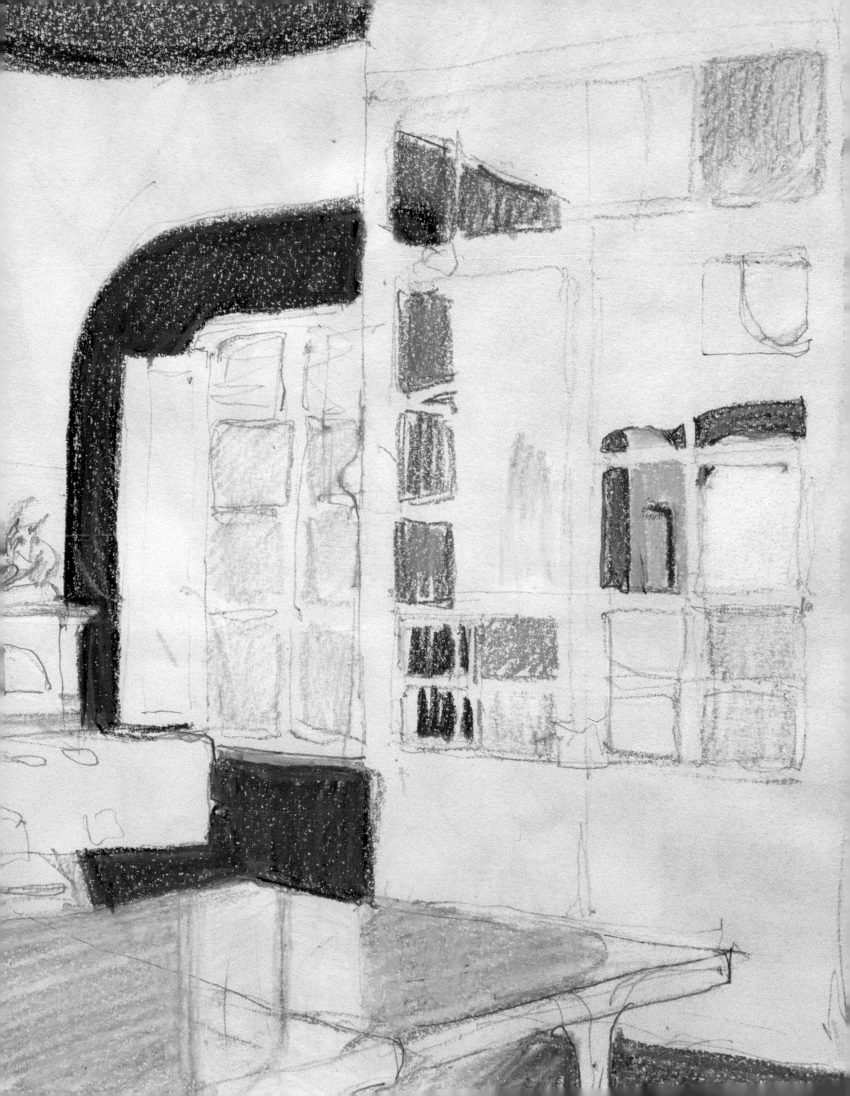

Getting the
materials

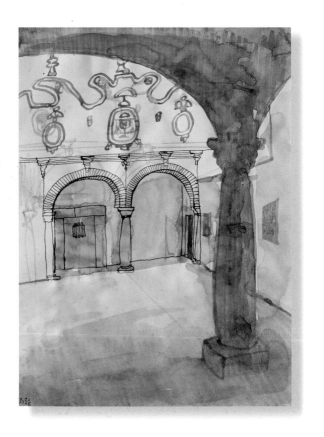

most out of
and mediums
Artists use different techniques
and methods for creating sketches,

many of them conditioned by the tool used to
sketch. The fact that many tools are within your reach makes it possible to
accomplish many sketches with different processes. At first, any technique is
good if you do not have another available or if you have chosen it freely.
However, to choose the most appropriate technique for each situation, you
need to know the advantages and disadvantages that each technique offers.
Trying different materials and practicing sketching with them not only will help
you to know and master techniques but also will make you understand the
subject you want to capture and will allow you to explore the variations
presented by each way of drawing.

pencils and Pens:
advantages and disadvantages

Charcoal and graphite sticks will allow you to move your hand freely and provide for interesting tone effects on the drawings. However, they are not very common tools in sketching. Let's see why.

SEVERAL DISADVANTAGES
Sketches usually are small-format creations, so working on them with sticks is a great inconvenience. Charcoal or graphite sticks produce lines that are too wide; the utensils are very delicate, fragile, and messy, and they can easily stain your hands. If, despite all that, you prefer to work with charcoal or graphite, you will have to draw on large-size paper. Before you do so, cut the stick in sizes smaller than an inch and a half, and work with different inclines, to reduce and get different variations in the width of the lines.

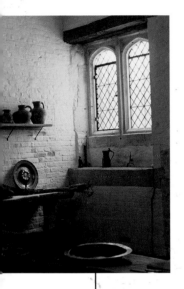

1

2

3

1. Begin the sketch by working with the tip of the graphite stick to create a outline of the interior. The line has to be soft to easily integrate with the shadows.

2. Take a stick a little less than an inch long and use it on its wider side. It will give you a rough shadow with little precision and no details.

3. Draw the darker shadow areas, the window lines, and the objects on the shelf with the tip of the stick. To achieve more precision, you can complement the work with a graphite pencil of the same color.

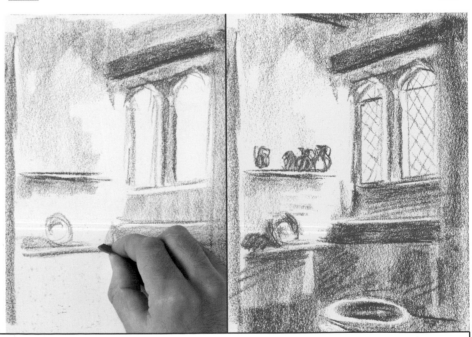

PENCILS ARE BETTER

In small sketches or when you require lines and more detail, you can combine charcoal sticks with carbon or graphite pencils. These utensils are very effective for drawing from nature, especially landscapes. Pencils, despite presenting a more intense line that is harder to blend than those of the sticks, are less messy, are easier to carry, and do not break. Softer charcoal and graphite pencils are ideal for working in drawing notebooks and making quick sketches.

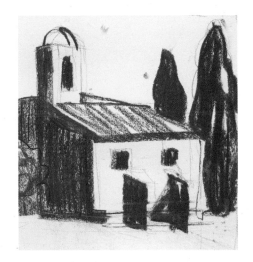

Using colored paper as a base for the drawing, with a reduced tone range of pastels, you can achieve very interesting results.

1. Working with charcoal sticks is more stimulating if you complement the work with a charcoal pencil. Rough in a light outline. Create the first layer of shadow with the charcoal stick.

In small sketches, it is easier to use charcoal and graphite pencils, rather than sticks.

2. Then blend the tones with a clean cotton cloth. This will reduce the tone of the shadows and make the pencil lines stand out.

3. With a composite charcoal pencil, superimpose a linear treatment on the shadows. This way, lines and spots will integrate perfectly.

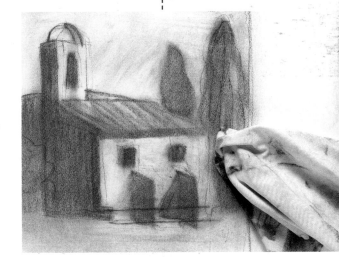

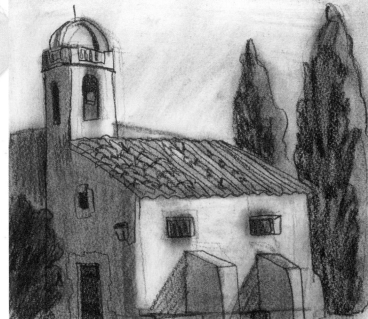

sketching with Ink wash
achieving rich tones

Sketching with ink wash and a brush seems much harder than working with a pencil or a pen. Painting is a more complicated technique to handle in hurried situations than drawing, but it also offers, when you are interpreting a subject, a very wide range of possibilities. Ink wash offers a wonderful range of tones for painting indoor scenes and landscapes.

QUICK SHADOWS

When you are sketching, time is of the essence, which means you have to use the most immediate and fastest techniques within your reach. Implementing an ink wash, with ink or watercolor, is one of these. It allows you to create shadows in the drawing in just a few seconds, very quickly. That is why it is not unusual to find this technique combined with pencil, pen, markers, or pastels. When working with ink wash, you must recognize that each spot on the paper is visible if you do not cover it with something opaque.

Ink wash allows for a quick shading of the model. Once the sketch is dry, it is even possible to add white pencil highlighting to give texture to vegetation.

On many occasions, ink wash is a complement to graphite pencil drawings, such as in these sketches by Teresa Galcerán. The space, perspective, and structure problems are solved with a pencil. The sketch is completed with ink wash in neutral colors that give a monochromatic nuance to the work

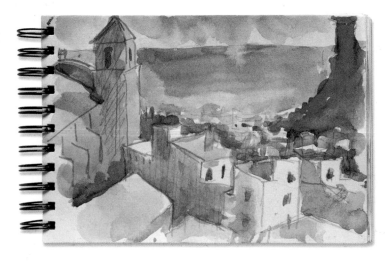

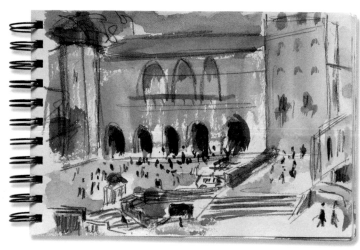

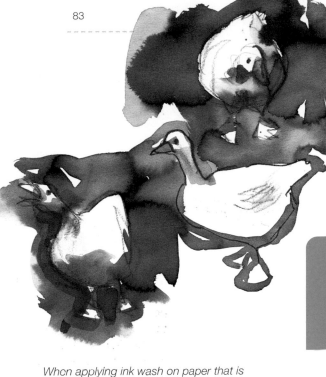

CONSIDERING THE PAPER

When you use a wet technique, the paper in a conventional sketchbook will warp, although once it is dry, it will recover part of its initial form. Sometimes this is part of the charm of a quick sketch. However, to minimize warping the paper when using watercolors or ink washes, it is best to select a sketchbook with thick paper.

COLOR PENCILS AND INK WASH

Watercolor pencils gather in one tool the characteristics of graphite or pastel pencils with the flow and tone richness of the ink wash. Every artist should have a small selection of watercolor pencils for drawing outdoors.

1. Sketching with watercolor pencils is done the same way as with graphite pencils, because they share the same graphic techniques.

2. The difference from other drawing methods is that you can easily dilute the color lines with a brush wet with water.

3. Drawing with watercolor pencils does not mean that you must merge all lines in the same way. The appeal of this technique is to know how to combine the watercolor areas with the lines that you decide to leave untouched.

When applying ink wash on paper that is not very absorbent, you create "puddles" that look like circular spots. This is an example of these spots, the purplish ink wash around the geese.

To create this sketch, you need to use two watercolor pencils that are very far apart from each other on the color wheel, one black and the other one yellow.

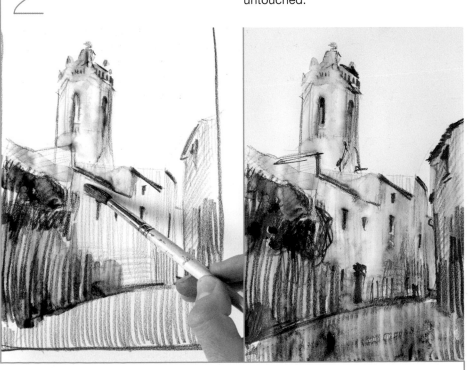

Ballpoint pens are designed for drawing lines very quickly without impacting the quality of the lines. They are ideal for representing action, movement, and busy models.

the Ballpoint pen,
a shorthand instrument

If you do not have your usual drawing tools, you can use a ballpoint pen and a paper napkin or a piece of paper to sketch something that attracts your attention. Ballpoint pens, although they are not part of the usual list of utensils with which to draw, are very useful for sketching because of their precision, quickness, and ease of use.

THE QUICKEST DRAWING
Ballpoint pens are the most-used tools for scribbling. Such scribbles are made extremely quickly, and they have multiple wandering and twisting lines, products of the turns of the ballpoint pen on the paper. The main inconvenience with their use is precision and consistency of the line, because they are limited by having an extremely thin tip. This narrowness is essential for doing detail work, but it limits the possibilities when you are looking for fresh results. There are two types of ballpoint pens: (1) those with a spherical tip, which are not water soluble, and (2) those that are water based, which have a flat, metallic tip that dilutes the ink if you pass a wet brush over the top.

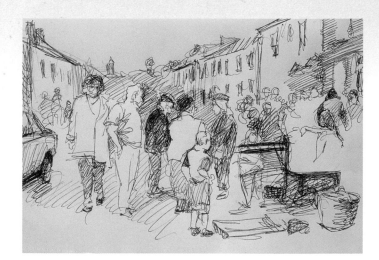

The ballpoint pen is designed to make outlines very quickly without affecting the quality of the line. Thus, it is a suitable medium for representing action, movement, and activity.

It's a given that the pen creates a permanent line without variations in thickness or boldness. Shadows and depth can be created by shading areas with zig-zagged and superimposed lines.

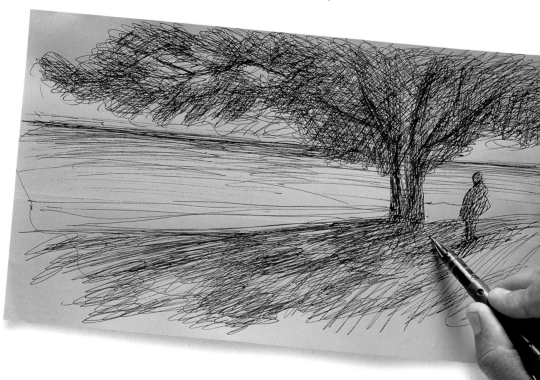

PRACTICING WITH A BALLPOINT PEN

When practicing with a ballpoint pen, it is advisable to select an easy subject and sketch with a frenetic hand movement, almost without thinking. The form is suggested by a play of rhythms that connect in different directions, which creates a three-dimensional effect. The execution of these quick lines facilities the intense expression of a heartfelt perception. It is a good idea to alternate different types of lines, such as spiral, figure-eight, and zigzag lines, superimposing them to give the feeling of a shape with volume and different movements.

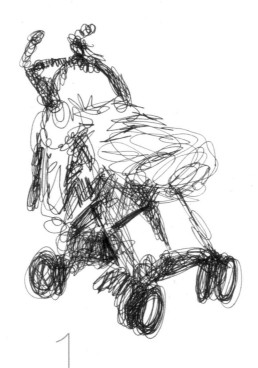

Ballpoint pens do not create broad shadows, so you will need to overlap the lines to create areas with an even tone.

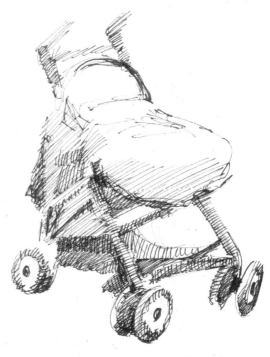

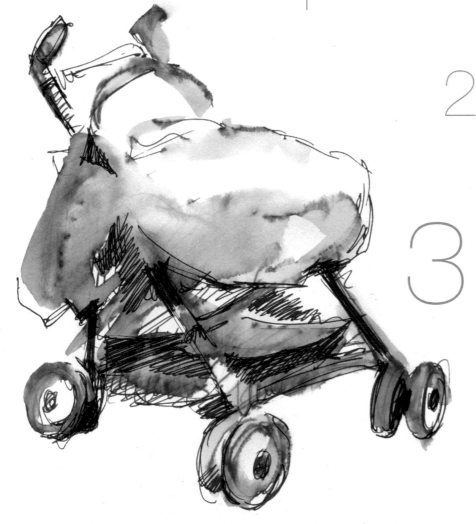

1. There are three basic ways to work with a ballpoint. The first one is to do an anarchical line similar to the scribbling mentioned previously. The darker tones look more insistent.

2. The second option requires that you make the object more structured and ordered. With this method, there is more respect for the blank sheet of paper and the composition of the object being rendered.

3. The last possibility unites two techniques in one. First, draw a sketch with a red ballpoint pen and dilute it with a brush. When the paper is dry, highlight some contrasts with a blue ballpoint.

Markers and metal pens have different characteristics. Both base their work on ink; however, the first one is more immediate and lets you work quickly, whereas the second one requires slow, deliberate work. The latter is more appropriate as a complement to other techniques mentioned previously.

sketching with Markers and pens

MARKERS

Markers offer a thin and flowing line that can be modified, depending on the emphasis that you put on the drawing. The line appears to be even, although its intensity and thickness can be altered by tilting the tip and changing the speed of the line. There is a wide variety of thicknesses of markers and of ink types from which to choose. You should experiment with different markers to find the ones most suitable for your needs.

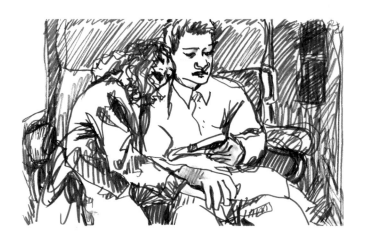

Markers offer a thick and intense line. They allow you to draw quickly, although they do not allow any margin for error.

1

1. When you combine two markers of different colors, it is preferable to sketch with the lighter one.

2

2. With the other one, you can cover the shaded areas. This will optimize the effect of the sketch.

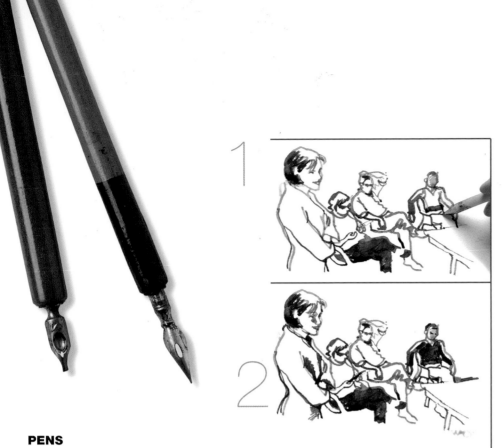

Having a used marker handy to fix medium-intensity shadows is a good idea. Use of this utensil will lessen the intensity from the line and will produce a more granulated and integrated line.

PENS

Pens are used in sketching as a complement to other techniques, not as a technique unto itself. The work process is a slow one, so it is not very suitable for creating drawings that are complex. It is very useful when rendering architectural details, introducing lines on drawings with ink wash, or serving as a complement to pencil lines. If you work only with a pen, it is possible to leave parts of the drawing incomplete so as not to be slowed down by superfluous details.

1. An alternative to the metallic pen is the reed pen. Reeds provide thicker and more variable lines.
2. Reed pens, like markers and pens, do not allow for corrections, so you will have to think carefully about every line.

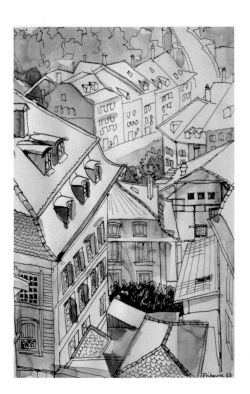

In sketches, pens generally are utilized as a complement to ink wash, to go over outlines, and to better define details.

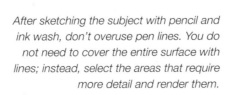

After sketching the subject with pencil and ink wash, don't overuse pen lines. You do not need to cover the entire surface with lines; instead, select the areas that require more detail and render them.

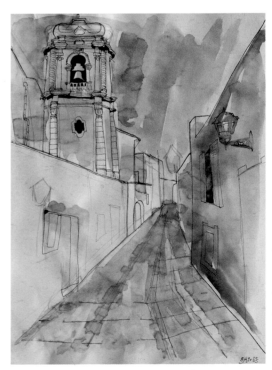

Sketching
on color paper

If you first cover the surface of the paper with color, using watercolors, pastels, or acrylics, you will create a color background on which to shade and harmoniously integrate your sketch without the sharp contrast of white paper.

A COLOR BASE

The logical reason to justify working on a colored background is that when working on a neutral background, the lights (white highlights) and shadows (ink wash or shadowed with pencil) can be deployed in all their tone ranges. The ideal tools for working on these backgrounds are those that offer an opaque line, among them color pencils, markers, ink, and the like.

DYEING PAPER

For sketching, you can use loose pieces of color paper or select from a variety of sketchbooks with color paper. If your sketchbook does not have color paper, you can prepare an ink wash with watercolor or acrylic and paint the paper. This can be done a few days before sketching to let it dry. Each of the double pages in your sketchbook can be painted a different color.

It is a good idea to have a few pages ready in neutral colors in your sketchbook. You can always use them to highlight your sketches.

A

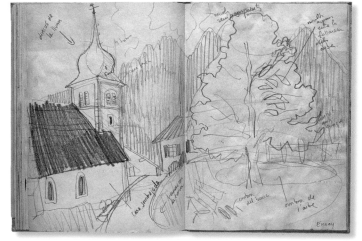

B

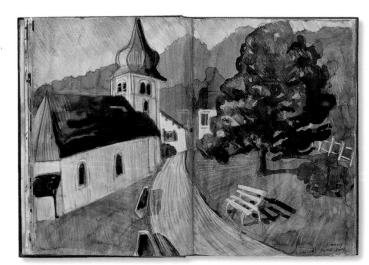

A and B. This is an example of the potential use of color paper as a medium on which to sketch. On the first double page (A), the artist has sketched and indicated the direction and intensity of the light. The second version (B), on color paper, was done a few hours later, in the artist's studio, following the instructions of the previous sketch.

ARE ALL COLORS OK?

Some colors are better than others for backgrounds. Definitely, not any color will do. Let's take a look at the best colors to use.

Gray, beige, and ochre tones are perfect; anything on the white-black color scale allows for a large variety of gray. They are the best backgrounds for drawing landscapes and indoor scenes. Blue tones give a feeling of coolness to landscapes and still lifes.

LESS DESIRABLE COLORS

Greens seem, at first, a perfect base color for landscapes, but the abundance and variety of green tones in nature make the combination difficult. Red makes it very hard to achieve a tone balance. However, you can also achieve spectacular effects with a red background. Yellow is too bright and does not let white highlighting stand out. This color makes it hard to harmonize the tones in your sketch.

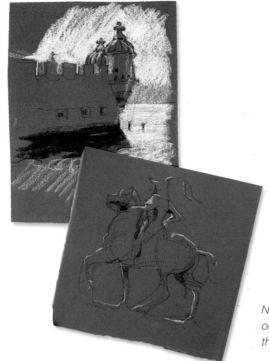

Sketches on neutral-tone papers are suitable for colored pencils, pastels, or white wax crayons. These highlights give volume to the model.

Neutral colors such as beige, gray, or ochre are the best, because they tolerate black or white lines.

Green, yellow, and red are not recommended because of their high saturation. They adversely affect the tone development of the sketch.

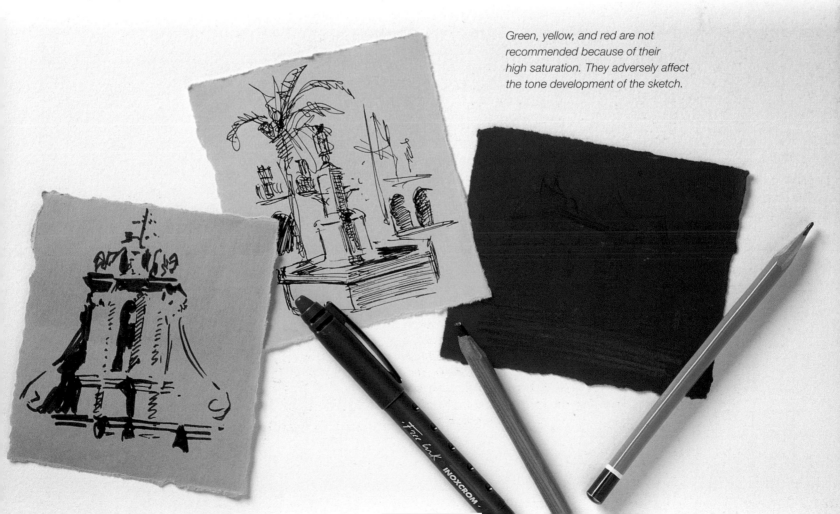

Corrections and touch-ups

When working with charcoal or graphite, it is common practice to guess at the lines that are underneath. Avoid erasing and blending, because you will blacken the lines.

erasers are never used in sketching. Professional artists' corrections and repeated lines are left in deliberately, to give more vitality and expression. They are called touch-ups.

DRAWINGS WITH SMUDGES AND DOUBLE LINES

When sketching, do not erase. Modify your errors on the go, blending with your finger or with new superimposed lines. Sketches are an experimental and changing process, and the study of forms allows for some adjustments and incorrect lines. Part of the creative process is to correct and add our errors to the finished drawing.

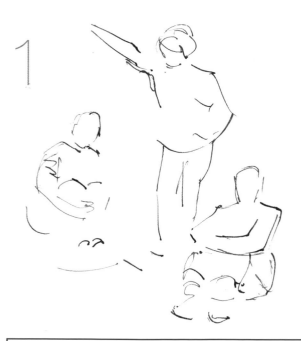

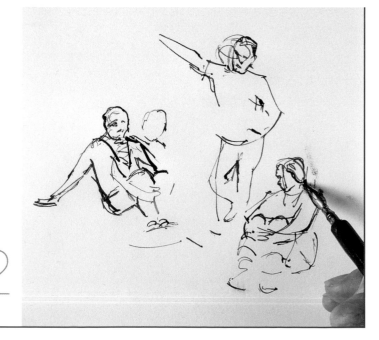

1. Touch-ups are very frequently done with pens, because the lines cannot be deleted or modified. Like any drawing with a pen and ink, you must begin with an outline sketch.

2. As the drawing progresses, you will modify and change the postures of the characters. You can leave the lines of the previous drawing exposed as if they were touch-ups.

ACCUMULATION OF LINES

Charcoal or graphite drawings can be done with endless superimposed lines that will be deleted and corrected during the work process. This accumulation of ghost lines gives an interesting tone effect on the background of the paper, sometimes even producing a more vivid result and adding variety to the drawing. As the drawing becomes finalized, those lines with more thickness and intensity become stronger.

UNFINISHED DRAWINGS

Sometimes, focusing excessively on reproducing a detail can slow down the process of completing the drawing, and the result may seem unfinished. A sketch must be a very direct response. If an unfinished drawing is suggestive enough and achieves the effects you intend to make, it must be left as is. Another option is to finalize some areas more than others to create contrasts of planes.

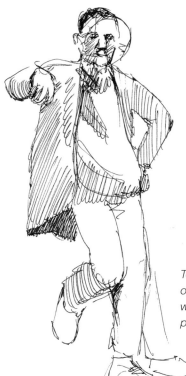

If, when you are drawing a model, you reach the edge of your piece of paper, you can glue another piece onto one of the ends. Doing so will give you more room in which to draw.

Touch-ups are applied by adding new lines on the previous ones, superimposing lines with more intense and more definitive profiles.

You are not obligated to fill the entire paper. You can focus on a detail and not complete the drawing.

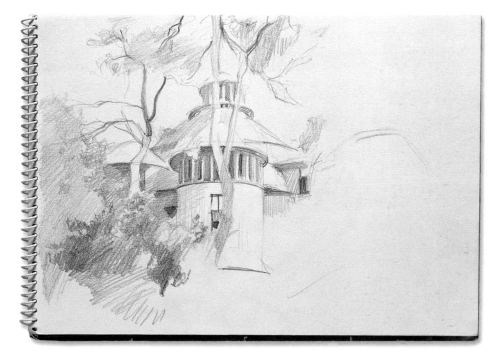

The sketch can be left unfinished if you decide that it achieves the objective for which it was created and conveys the essence that you want it to. It doesn't matter whether the earlier, partial pencil lines are visible or not.

Sketching
en plein air

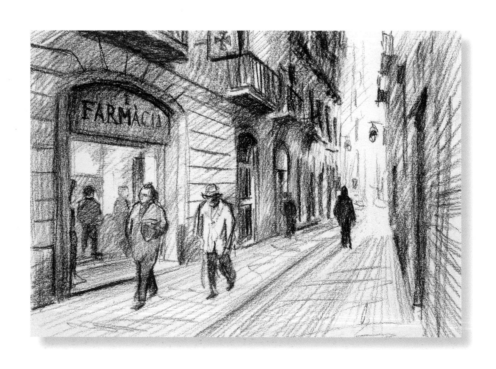

ÒSCAR SANCHÍS. SMALL STREET IN BARCELONA, 2005.
GRAPHITE PENCIL.

Drawing from nature
or out-of-doors

offers the possibility of sketching outside a studio, in contact with the real subjects. The main purpose for doing so is to research and perceive the subjects in different weather conditions and in changing mobility. Ultimately, such sketches intend to capture, precisely and quickly, the changes wrought by weather, light, and reflection. With just one look around you, you can find thousands of themes within reach, during a stroll in the countryside, on a busy street, or in a park in a big city.

drawing from nature
just by turning your head

drawing from nature has been the main subject of art instruction for centuries, and it continues to be a classical theme for art students and veteran artists alike. It is the best way to learn to draw, because in front of the real model you will be able to appreciate the details, change the point of view as you please, and look attentively at any element.

THE LIVELINESS OF SKETCHES
What makes a sketch interesting is its agility, achieved basically by working from nature. Observing the movement, the real volume, and the environment will give you a lot of information that will remain in your mind and that you can incorporate later in your sketch.

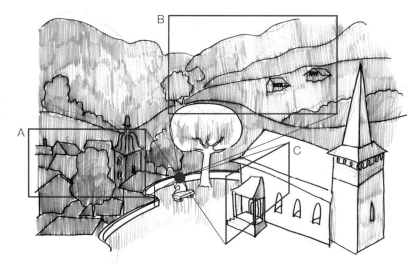

This schematic drawing clarifies the position of the artist when doing the sketches below. For each frame, he has rotated his position by 90 degrees.

A

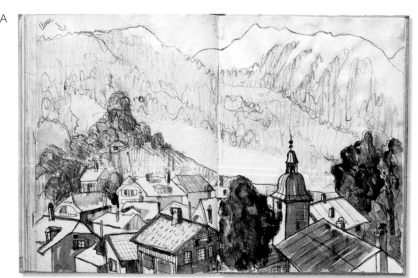

B

THE PROBLEM WITH PHOTOS

If you get accustomed to continuously using photos as a reference, you will be taking the risk of not understanding the theme. The photo helps the artist to establish proportions, colors, and details, but the general composition and the intendent nuances arise only from direct observation. Attempting to capture movement, perspective, or different color nuances and shapes from photos is difficult, because lenses and the development process tamper with and often "flatten" the subject. Also, we are often conditioned by the frame of the camera instead of selecting our own frames in front of the actual model.

DRAWING IN PUBLIC

When you first start to draw, you may be embarrassed to do so in public. Other people may realize that they are being observed and may become upset or come over to see your work. Trying to draw without being seen is not useful either, if you want to develop your skills with sketching. To overcome these situations you must face them decisively, without fear.

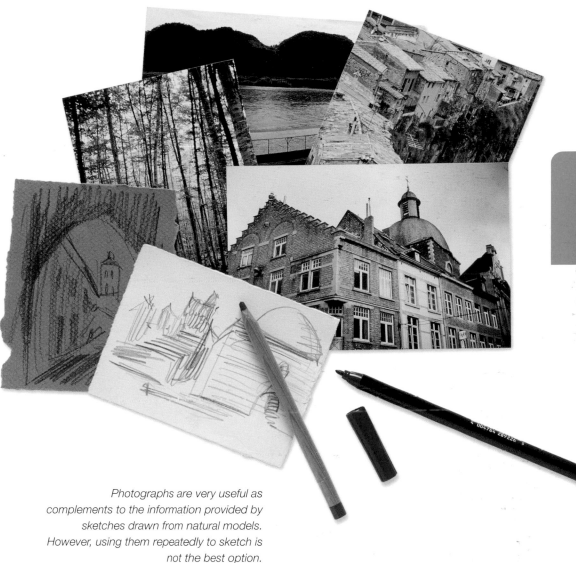

Photographs are very useful as complements to the information provided by sketches drawn from natural models. However, using them repeatedly to sketch is not the best option.

C

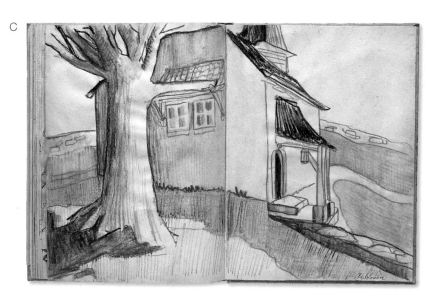

A, B, and C. Drawing outdoors means selecting the model by just turning your head. From a fixed point, if you move your eyes slightly, the subject changes and becomes a different one. For example, look at these three frames that are adjoining in space. They have been done by moving the viewing position by 90 degrees in each case.

to draw outdoors you need only your necessary materials, depending on your personal style, and the sketch that you are going to draw. Initially a sketchbook and a small box with different tools will suffice, all put into a bag or backpack to allow you to walk and draw.

the Artist's bag

THE WORLD IN A BACKPACK

Everything you are going to need should fit in a small backpack. It is advisable to have the following materials: a small pencil case with graphite pencils of different degrees, colored pencils, a pencil sharpener, markers, pens, and China ink or watercolors (two or three brushes of marten hair, numbers 4, 6, and 10). Also bring along one or two hardcover sketchbooks of different sizes, a bottle of water if you are going to use ink wash, and a packet of tissues. It is advisable to avoid taking anything that is not useful.

In the bag or backpack put a selection of pencils, sticks, pens, brushes, and sketchbooks of different sizes. If you need to carry ink, place it in jars with tight-fitting lids.

What's shown here is the minimal equipment for a sketch artist. You should always carry with you a small notebook and a couple of pencils that can fit in a bag or in a pocket.

FOR YOUR CONVENIENCE

The inconveniences of drawing outdoors are of a practical nature—problems such as the most comfortable way to carry materials and the equipment needed to protect yourself from the weather. In terms of the weather, you will need only a hat or cap to protect you from the sun and a raincoat in case you get caught in a storm. It helps to have a firm support, such as a piece of cardboard or wood, and adhesive tape if you do not have a sketchbook and you choose to draw on loose paper. Some people use a folding stool and a rattan mat; others prefer to find a comfortable rock on which to sit. Try to avoid carrying easels or umbrellas.

It is worthwhile to carry a hat to protect yourself from the sun. This is the most useful type of hat because it takes up very little room in a backpack.

If you are going to work with loose paper, you should have a hard surface and adhesive tape. The dimensions of the surface must be small enough to fit in a bag or backpack.

Take the weather into account, especially if you are in the mountains. It is advisable to carry a raincoat that can be folded without taking up too much space.

the Importance
of a sketchbook

a sketchbook is your most personal element as an artist, because it reveals a lot of your personality through the subjects that have attracted your attention and the way you have selected what seemed interesting to you. Like a professional photographer always carries a camera, you must carry a sketchbook and a pencil.

VERY PERSONAL
If drawings of a larger format have a public character and their purpose is to be viewed, the value of a sketchbook is to contain very personal information for you as an artist that can also become a document of your experience and your personal progress. The pad is the place where you can think freely, randomly, and without being judged. However, it cannot be helped if some works are destined to failure.

Don't be afraid of making mistakes or drawing poorly. Your pad of visual notes is personal, and if you do not feel comfortable doing so, you are not obliged to show it to anyone, so you can work without inhibition.

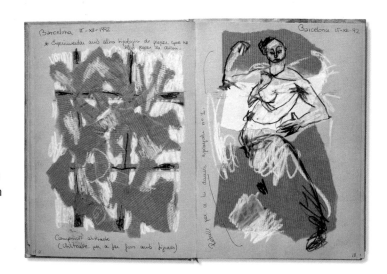

The sketchbook is the ideal work frame to experiment: gluing paper, working with new tools, graphics, and interpretations.

The sketchbook is comparable to a photo album because you will often include portraits of your friends, intimate notes, or representation of your fears or obsessions.

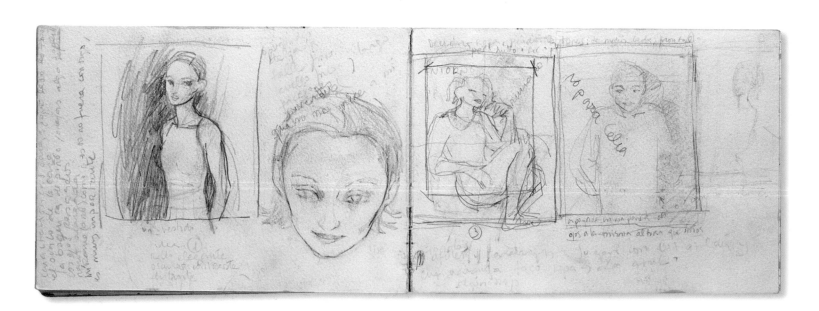

PRELIMINARY SKETCHES

You should consider the sketchbook the most essential element of your equipment, something to use frequently, especially to draw preliminary sketches. Preliminary sketches are notes and quick sketches to learn to improve and attain a certain level of proficiency. They are like a warm-up of sorts, done so that it will not be so difficult to begin sketching in earnest later on. You should work on preliminary sketches for about 10 minutes a day; be sure to check your progress over time.

WRITTEN NOTES AND INTERPRETATIONS

The sketchbook may contain written notes as well as drawings. These notes can be used to mention important details; serve as a future reference; comment on the weather; indicate environmental elements; or record subjective impressions, ideas, dates, places, or color ideas that arise when you are observing the subject. Anything you don't want to leave up to your memory must be in the notes.

Many times, a napkin can become an improvised canvas on which to sketch or reflect an idea.

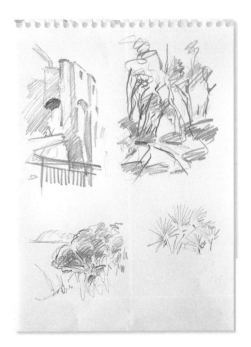

Notes are commonly written on sketches to reflect information on light, the frame, or chromatic impressions of the sketch.

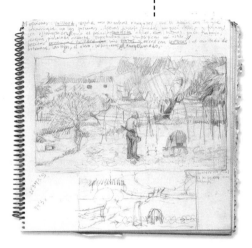

The sketchbook must also function like a drawer, where you can throw your improvised and quick drawings, your preliminary sketches.

You must treat the sketchbook as a testing ground; use it to develop your personal style, plan your next sketch, or practice new graphics or original interpretations of a subject.

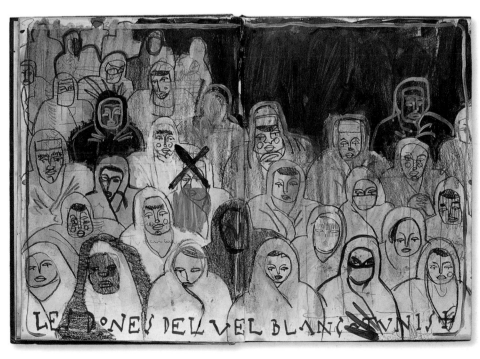

types of Sketchbooks
and their use

A rectangular bound sketchbook is the most popular one among artists.

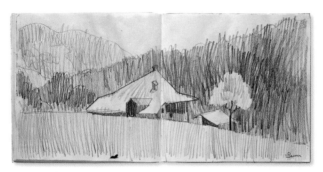

The square sketchbook allows you to draw panoramic views wider than what could appear on a page in a rectangular sketchbook.

the boundaries of the drawing are determined by the dimensions of the sketchbook, so picking the most appropriate sketchbook for your needs is important. You must also decide whether to use only one sketchbook for all your drawings or different sketchbooks for each subject.

SKETCHBOOK SIZES
The dimensions of the sketchbook are standard and cannot always accommodate the sketches you want to draw. Therefore, before buying a sketchbook, you must decide what page format you prefer. Generally speaking, sketchbooks are rectangular. Square sketchbooks are not easy to find, but they can be found in specialty stores. Working with loose paper affords you a greater range of paper quality, size, and shapes but requires the use of a binder or portfolio.

You can find sketchbooks of different shapes and with different paper quality and colors.

SELECTING THE FRAME

The frame of the drawing on the page of the sketchbook must be a matter of instinct. You can use the double-page format to frame the sketch: a landscape-page format to emphasize the width of the landscape, a portrait format to produce an intense and dynamic effect, and so on. When you use a double page to adapt to the bound sketchbook, there are two options: ignore the center line completely and work as if it did not exist, or integrate the line in the sketch composition.

AVOIDING THE CARBON-COPY EFFECT

If you are going to draw on the back of a page you have already used, you should place a piece of bristol board under it to prevent the preceding drawing from tranferring to another page. You can also place your hands on the bristol board when working on the opposite page so that you do not smear the sketch. Once you have finished the sketch, if the page is still wet and you want to draw on another page, you should put absorbent paper between the pages to prevent the drawing from transferring.

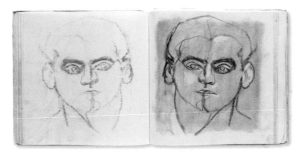

When sketching, you should protect your work. If you turn the page and draw on the back of a sheet, the preceding drawing will transfer onto its facing page.

Before buying a sketchbook, you should check the thickness of the paper. It has to be heavy enough to use for lines and ink wash without warping excessively.

Before turning the page, place a piece of bristol board on the opposite page.

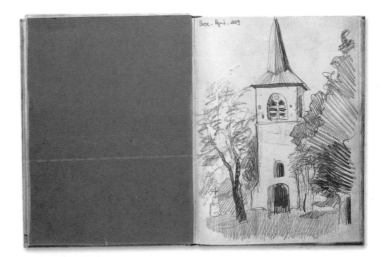

This way, you will prevent the preceding drawing from transferring to its facing page.

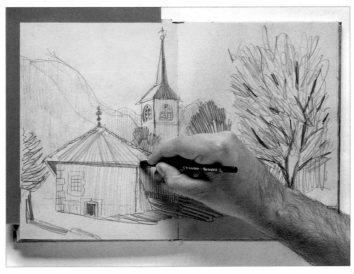

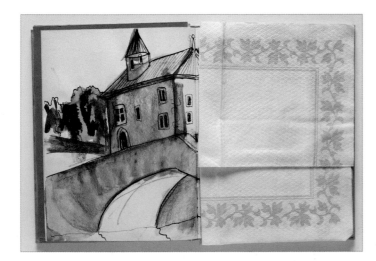

If when finished with a series of drawings some of the watercolors are still wet, lightly press a napkin or paper towel against the moist surfaces.

sketching during a Trip,
sketching on the road

trips provide an opportunity and a reason to draw. These sketches are quick records of impressions and memories during the trip; they reflect, in brief, vivid moments and emotions. They are loose sketches done in a relaxed way, with a fresh and open eye. Gathered in a sketchbook, they are an interesting record of the places you have visited.

DRAWING PICTURESQUE SCENES
Sketches made during vacations are in principle similar to those done at any other time. But you might tend to give the works of art more attention when you are on vacation, because the environment you are sketching is very different than the environments you are used to drawing. Or perhaps, under these circumstances, you just have more time to thoroughly observe everything around you.

Sketches of travels are a reflection of your amazement at a picturesque landscape, the local architecture, or the large monuments of the past.

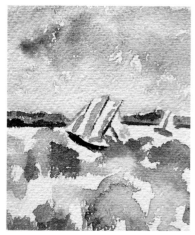

Boat trips or sailing trips provide good opportunities for sketching; capture some aspects of the trip in your sketchbook.

Sketches of landscapes attempt to capture the distinctive aspects of the landscapes you have visited.

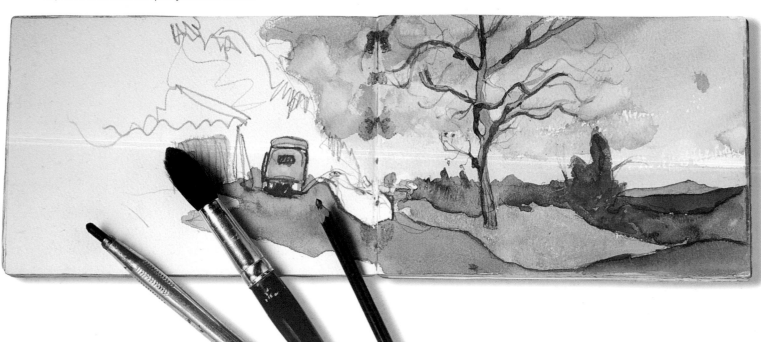

EASY MATERIALS TO TRANSPORT

The materials used to sketch during a trip are the most basic and easy to transport. Bound sketchbooks must be small, to fit in a handbag or in a pocket. To draw, a pencil or pen will suffice.

WAITING AREAS

Sketching while you travel means that you have to use your waiting time wisely. While you are waiting in an airport, a train station, a bus station, or any other transportation area, you can open your notebook and take quick visual notes of your environment.

SKETCHES LATER ON

You can draw quick sketches when you are outside, and you can leave the details for more relaxed and peaceful moments in a hotel room or apartment. During the day, take the quick sketches outdoors; later, inside, try to create new and more elaborate versions of them, working with ink wash and other materials. Take the necessary time to focus on a specific theme for as long as you still remember it.

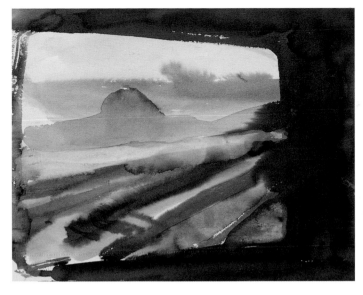

If you travel by train you can draw the landscape that you see out the window. This exercise requires that you draw quickly and have a very good memory.

Sketching in a moving car is a real challenge. The movement makes it difficult to maintain control of the image and creates a shaky line.

When you are in front of the model, you can draw small sketches that capture the essence of the architecture. Then, at night, in your room, you can create more elaborate sketches with ink wash and pen.

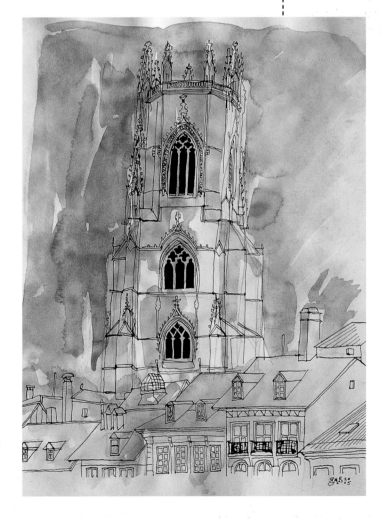

fixing Shadows,
sharpening contrasts

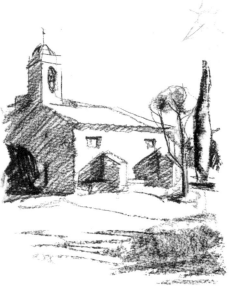

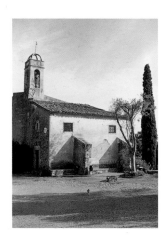

if you paint outdoors on a sunny day, you must be very aware of the light, the position of the sun, and the movement of shadows as the day progresses, and you must put into practice strategies to fix the shadows and show the direction of the light source in the sketch.

SHADOWS MOVE
When working outdoors, many artists draw the model with linear forms and place the shadows first, using stripes drawn with a graphite pencil or gray, brown, or blue ink wash.

This method of sketching enables you to "freeze" the shadows in time. You need to work this way if you are going to do a sketch over a long period of time, because while you are drawing, the sun moves and the shadows change shapes.

Once the linear drawing is created, a good way to fix the shadows is to quickly draw diagonal stripes, following the direction of the source of light.

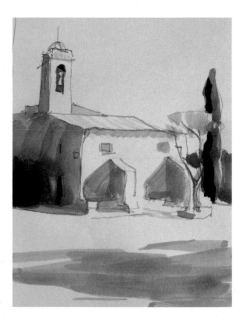

Fixing the shadows with ink wash is a much quicker way than the method used in the previous sketch. However, you need to wait for the washed areas to dry before continuing with your drawing.

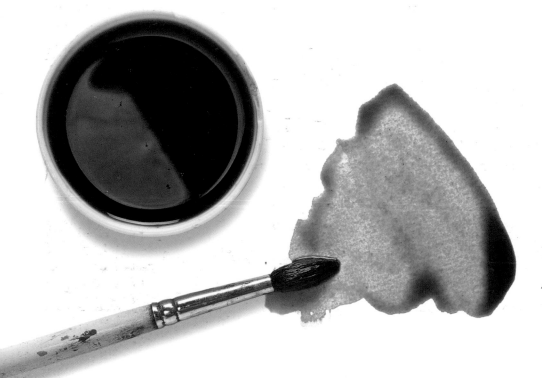

An ink wash is the quickest way to apply shadows.

POSITION OF THE SUN IN THE SKETCH

If you do a quick sketch and you do not have time to apply shadows, you can indicate the source of light in the top corner of the page by drawing either a sun or an arrow. This way, when you have more time to work on this sketch later on, you can easily apply the shadows. You will need only to imagine the areas that would be hidden from the light. Another option is to shadow only one element of the drawing. This provides the necessary information about the source of light and the intensity of the shadow. Later on, you can apply shadows to all the other components of the scene based on the sample element.

If you are sitting out in a field, consider the position of the sun. It is best to work with the light coming from your left (if you are right-handed) so that your body and your hand do not project their own shadows onto the paper, which would make the work much more complicated.

If you do not have enough time to apply all the shadows, you just need to place the position of the sun in the drawing, and then you can apply the shadows in a logical fashion when you have more time.

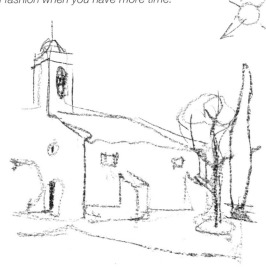

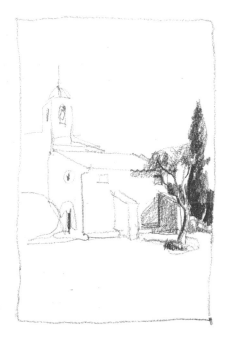

Another way to apply shadows is to shadow only part of the sketch. You can apply the rest of the shadows later, using the previously applied ones as a reference.

The light enters this room through the door. The shadows must be consistent with this light source, so the most intense shadows must be on the steps and behind the seated person.

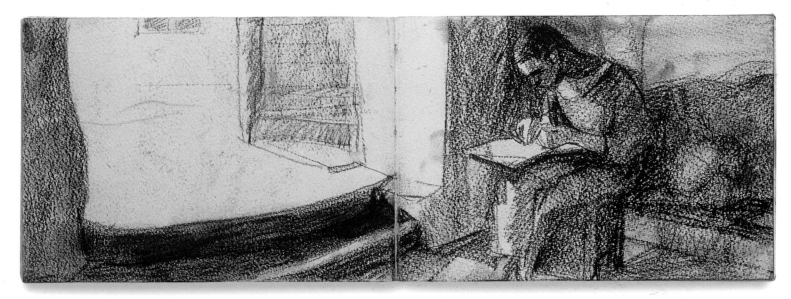

drawing
from memory

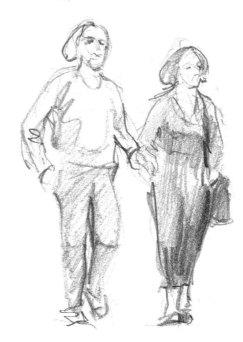

People are constantly moving, so very often it is necessary to invent some details to complete your sketch. It is useful to make a rough sketch of the actual model.

If you draw animals or the landscape you see from a moving train or on a busy street, you will have to use your memory, retaining the image in your mind, visualizing it for a few seconds, and trying to reproduce it on paper. Unless you are an expert artist, this simple operation will be a bit complicated, so you need to begin to practice this exercise.

RETAINING SIMPLE FORMS

The best way to retain an image is to visualize the subject in terms of its individual components and their relation to one another. For example, you can conceptualize a model's components as simple geometric shapes: circle, oval, and triangle. With practice, you can learn to utilize other shapes that will facilitate the spontaneous drawing of the sketches.

Taking into consideration that your model has already probably disappeared, using your rough sketch you can complete the drawing by incorporating the elements you remember with others that you make up.

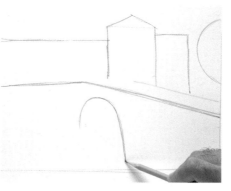

1

2

1. First, conceptualize the scene in terms of simple geometric shapes. Here, you record the curvature of the bridge and the quadrangular form of the houses.
2. In a second pass you can add some other forms to complete the previous ones.
3. In the finished drawing you can mix the shapes you remember with those that you make up to complete the drawing satisfactorily.

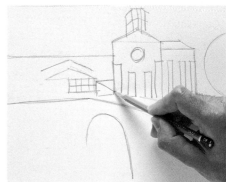

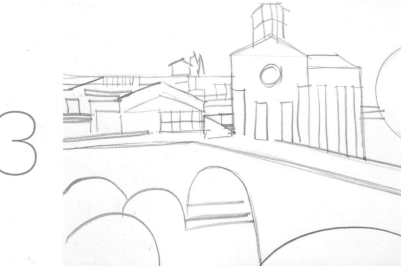

PRACTICING RETENTIVE MEMORY

Observe a model closely for one to five minutes. Then, turn away from it and try to draw the graphic image that you have in mind with as much detail as possible. Once you have finished the drawing, you can compare the model with your sketch, demonstrating your ability to observe and your accuracy. As in the quick sketch, the execution must be very brief. Regardless of how discouraging the results may seem at first, with practice you will improve, capturing the whole picture by process of instinctive elimination of all ancillary elements.

In your sketchbook you can draw small rough sketches to remember places, spaces, or people that you have met along the way. It is a good memory exercise.

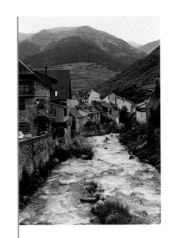

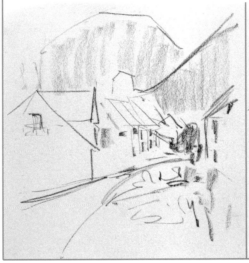

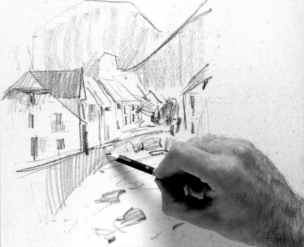

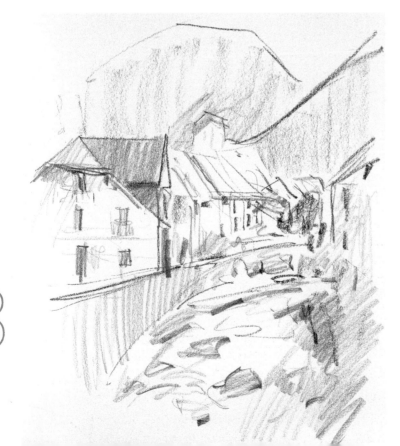

1. The artist has observed the model for a few minutes, and then he turns his back to it to check his ability of retention. The sketch is the most important part, because the image is still fresh in his mind.

2. As the sketch progresses and he feels the need to add details, he realizes that he has forgotten some details about the model. He must now improvise and make them up, if necessary.

3. The sketch is completed with more made-up items than remembered items. If you compare it with the real model, you will notice many modifications, elements that have disappeared and differences in the perception of proportions.

The most
appropriate

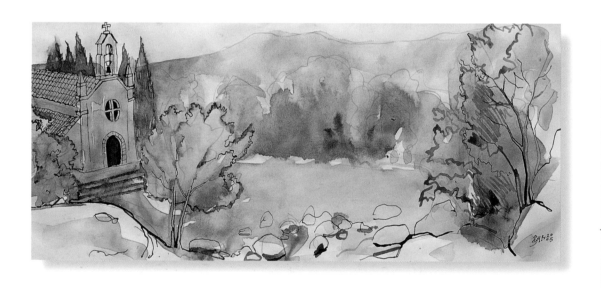

GABRIEL MARTIN. THE CHURCH OF BABY JESUS OF PRAGUE
IN SANT HILARI SACALM, 2005. INK WASH AND PEN.

subjects
For beginners the first models will be very

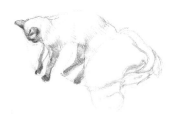

simple in form. You will gradually be able to sketch more complex forms. The most simple forms are still lifes and landscapes, and the most complex forms are urban scenes and the human figure. Being interested in a specific subject is a source of motivation that will keep the artist active. As you improve, you will also realize that some subjects are more appropriate for sketching than others. We discuss them in this chapter.

Natural landscapes

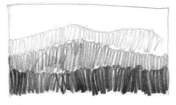

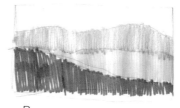

A B

C D

as the breadth of your travels increases, the variety of landscapes gathered in your sketchbook will also increase. All this effort results in many sketches that reflect the fascination you had with investigating your environment and the technical solutions you devised to render the subjects, with their infinite facets, effectively.

ORGANIZING THE LANDSCAPE
Artists do not draw the landscape as it is in real life. They often make some adjustments. That is why when you do a sketch of a landscape, you should organize the forms in a way that causes them to lead the eye through the drawing. Also, when selecting the observation point, you need to find a way to connect the elements in the foreground with those that are farther away, highlighting the foreground with strong light and shadow contrasts, and softening the background. The simplest images are often the most effective ones. Therefore, do not try to fill the paper with too many elements.

A. A good way to organize the foreground and background of a landscape is to follow the tone scale. The foreground is of a more intense tone and the background has softer tones.
B. You can use different means in one sketch to give more clarity to the drawing. Graphite or ink wash can be used for the background, and a marker for the foreground.
C. Creating a contrast between the lines of the foreground and the background ink wash is a somewhat similar process. Then, the contrasting techniques make the sketch easier to understand.
D. In a sketch done exclusively with lines in a net pattern, changing the direction of the lines may differentiate the foreground and the background. This contrast of lines helps give more clarity to the drawing.

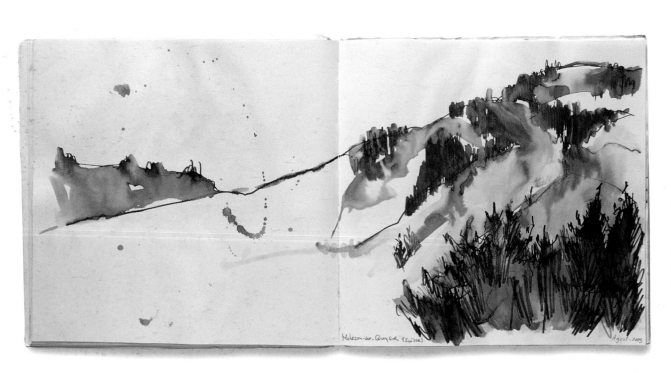

The simplicity of sketches is valued. They present an intense emotional charge rather than being more finished and detailed.

Landscape sketches usually give the sky a secondary importance. The vegetation and the landscape become the most important things in the sketch.

THE DANGER OF DETAILS

Sometimes, when sketching a landscape, you will realize that the view offers a large amount of details and nuances that can easily be included in the sketch. The biggest danger with rendering a natural landscape is falling into the error of sketching too many details because of the many textures in the vegetation. You don't have to draw trees leaf by leaf or to represent any of the veins in a tree trunk. To enable an object in a picture to be easily recognizable as a tree, just render the main forms of that particular species of tree. The shape is determined by the shape of the top and the distribution and breaks in the main branches. All this gives the tree a characteristic silhouette.

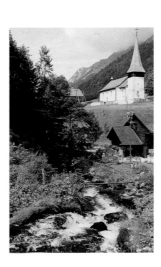

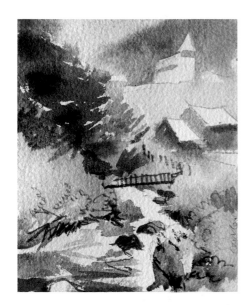

In sketching, there is no time for details and textures, and because of that, there are some other ways to suggest details. Here, the landscape shows signs of texture and detail only in the foreground.

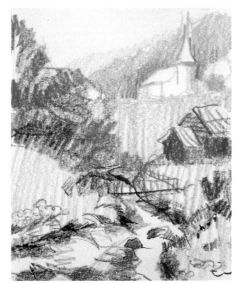

Another way to provide details is to vary the intensity of the line with distance; thus, the lines of the nearby vegetation are more carefully done than those of the vegetation next to the church.

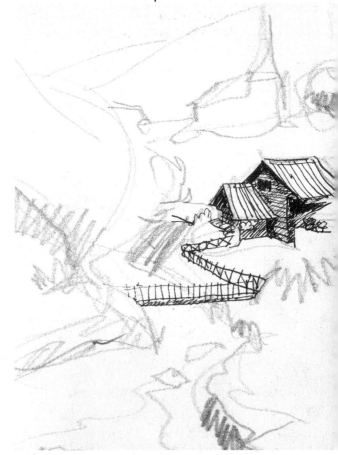

You could introduce some detail into only a few areas. This effect must be localized and not extend to the rest of the sketch. There is no time to apply detail to the entire sketch.

urban Sketches, buildings as a landscape

For many people, the city is a natural environment and the nearest available environment to sketch outdoors. In some ways, it is easier to capture the essential character of an urban landscape than of a natural landscape. That is so because the urban landscape has a more defined structure formed by the straight lines and the solid shapes of the buildings, whereas the rural landscape is usually amorphous and changing.

FORGETTING PERSPECTIVE

The biggest problem faced by the sketch artist with an urban landscape is the perspective of the buildings. If you decide to ignore the theory of perspective and completely trust your eyesight, you can often encounter images that do not quite fit perfectly.

No matter; sketches do not require precision. Spontaneity is more important than precision of geometric figures. Knowledge of the basic rules of perspective is not a requirement.

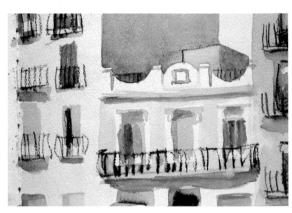

This is another example of an urban sketch in which there is no perspective. The facades lack depth.

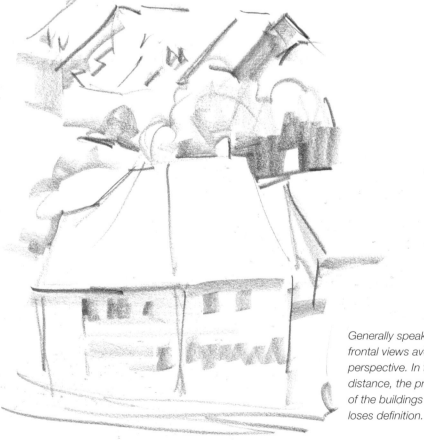

Perspective, although not critical, is useful to re-create the depth of a street.

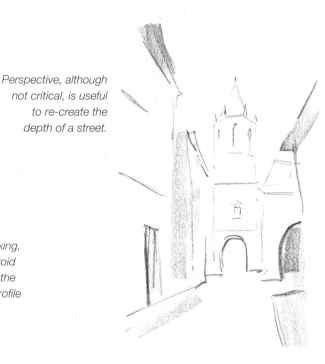

Generally speaking, frontal views avoid perspective. In the distance, the profile of the buildings loses definition.

BUILDINGS LOSE DETAIL IN THE DISTANCE

As with the process of sketching natural landscapes, the key to sketching an urban scene is to differentiate the foreground from the background. Using some harsh lines in the foreground and softer edges in the background helps define the buildings.

ARCHITECTURAL DETAILS

For those artists interested in detail, the forms of general building architecture offer a myriad of very interesting materials. A sketch does not have to consider aspects in general; instead, it may focus on just one detail (a window, a balcony, a column, and the like).

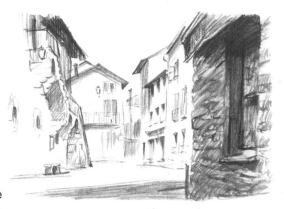

The facades in the foreground have darker tones and more lines than those in the background.

Don't worry if lines in your drawing are not completely straight and if measures are not accurate. Combining spontaneous lines with the natural distortions of the drawing adds a nice vividness to the sketch

The architectural details, such as fragments of a building, allow for a study of textures, ornaments, and details of the surfaces.

Urban vistas don't have to consist of just wide-open spaces in big cities; they can also be, for example, intimate spaces like this small interior patio.

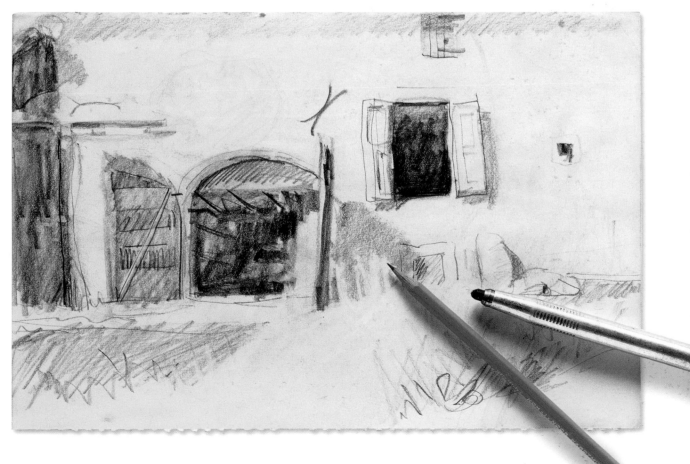

Sketching
interiors

the first interior that you should use as a model is an area of your own home. Even though interiors may seem plain and boring, you will be surprised by how different they are and the possibilities they offer when observed through different eyes. Interior spaces are a good environment to draw when the weather is bad and you have to stay indoors for a long time, or when you find yourself in waiting rooms, lobbies, or transportation stations.

LIMITING SPACE

When drawing interiors, you should first draw the space boundaries, the lines that define the angle of the room, the tops of the walls, and the ceiling, or a window frame in a light and shadow scene. Don't concern yourself too much with attaining the same accuracy that a perspective study would offer. In a sketch, you have more freedom to give more incline to architectural lines, to deform or improvise the interior space.

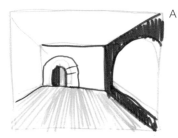

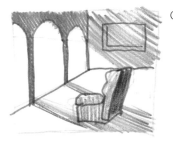

A and B. First you should define the space, projecting the lines of the wall and the ceiling of the room. This will allow you to establish the boundaries for the interior perspective.

C and D. Lighting is another key factor, because dramatization and spatial perception depend on it.

As with urban landscapes, when drawing interiors you can also avoid a perspective effect by delimiting the frame.

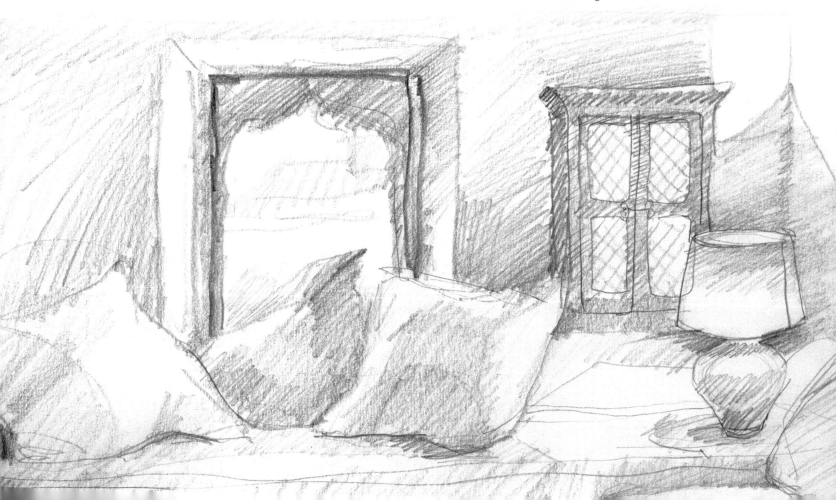

BROADENING INTERIOR SPACES

Some interiors offer an extremely broad viewing angle. They cannot be resolved with a conventional linear perspective, because the scope of vision is too broad; in these cases you have to give the interior an angular effect to create a feeling of scope and place. These drawings are distorted, and the forms of the drawing's periphery are abruptly curved to the center of the paper. An interior scene gets a new spatial dimension and more depth when a visible space through an open door or window is included, which will give more depth to the drawing and create another frame.

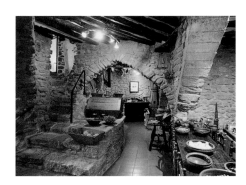

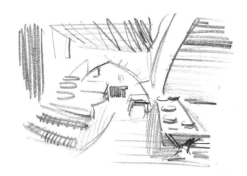

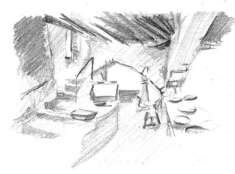

These are two quick sketches of the same interior. The dramatic effect is increased by exaggerating the perspective, the angular effect. This is especially evident in the incline of the beams of the ceiling and the base of the staircase.

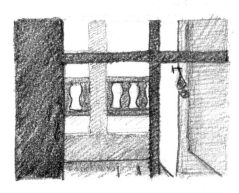

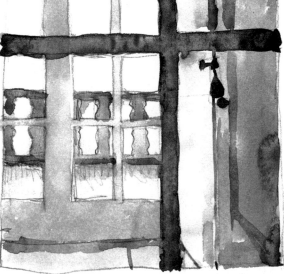

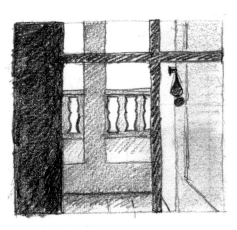

The window is an interesting interior element, because it broadens the space, opening it to the outside. These are four variations of the view through a window.

the human figure as a model

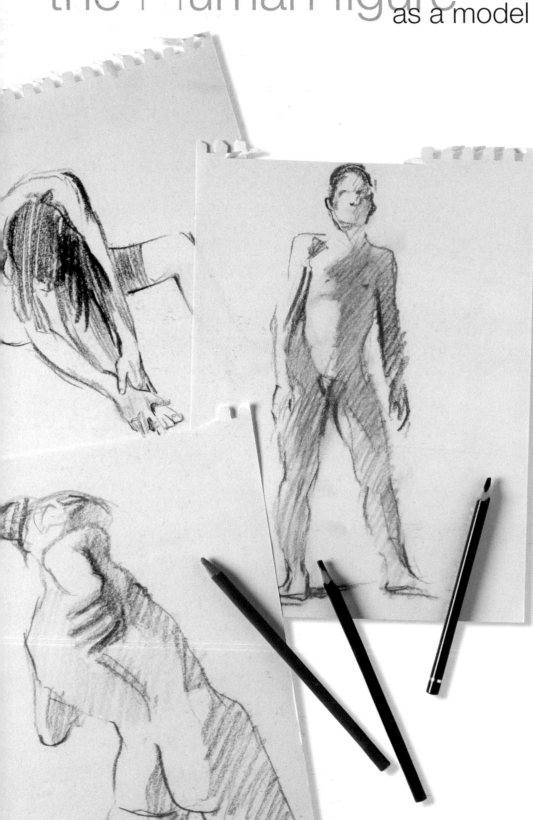

the human figure, nude or clothed, has always been an essential model in sketches. Sketching human models is more difficult for an inexperienced artist, because the proportions of the human body are so familiar to us that it is often difficult not to find fault with the drawings.

QUICK SKETCHES OF PEOPLE

Quick sketches of people do not allow us to start detailed studies of the body's anatomy: the anatomy details of the bone structure and muscles are less important than a good general description of the body, of the main forms, of the balance of the figure, its weight and its movement.

The key to sketching people is to observe thoroughly and use lines sparingly. These quick sketches must have the sole purpose of translating the complex forms of the body into a convincing and recognizable structure.

Nowadays, art academies and schools offer the possibility of sketching nude models. These exercises are an interesting practice ground for improving our perception of the human body.

CAPTURING THE RHYTHM OF THE FIGURE

The movement implicit in the human body, even when it remains in a stationary position, reveals elements of tension, in the form and posture the body takes. The tension of a pose is shown through the rhythm, an internal imaginary line that gives the feeling of flow, expression, and dynamism to the body. If you learn to view the rhythm of each figure and to represent it correctly, the essential gesture of the pose can be easily inferred.

Avoid a very detailed work of the body and the facial features. Remember that you are sketching, not drawing portraits or anatomical studies.

The most important thing when sketching a person is to capture his or her internal rhythm, identified with posture. In this case, you have sketched the profile of a pregnant woman.

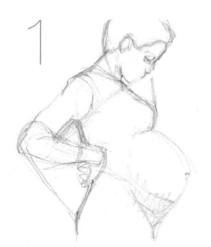

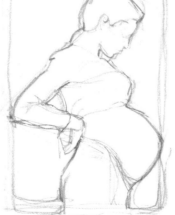

1. Work the profile of the body parts in the initial sketch, exaggerating if possible the curves of the body to highlight the posture. To create volume, you should intensify the roundness of the body.

2. Then, ignore the interior lines to center your attention in the exterior profile, and mark it with a thicker line. You can position the figure within a box, which can help you analyze the empty spaces around it.

3. Finally, work the tonal zones and the contrasts that accentuate the body curves. For example, notice the shadow in the underarm area.

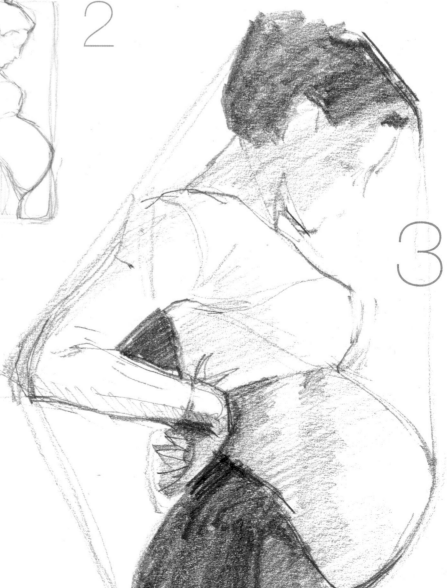

People and ambiance

there are many opportunities to draw people—for example, when our relatives visit us or when we encounter strangers on the streets, in the markets, and on various means of transportation. By observing and drawing people often, you will create a visual memory of physical forms, body language, and facial expressions in different situations.

INTEGRATION AND ATTITUDE OF THE FIGURE

Groups of figures are not treated as separate objects. They are sketched and look unfinished so that they blend with the background and become an integral part of the general environment.

A good part of what interests us about drawing people comes not from the physical features of the person but from how clothing and accessories are related to the body, to disguise or to highlight its shape. Another interesting thing to do is to capture in just a few lines the body's attitude, which partially explains the actions undertaken or about to be undertaken by the person who is being observed: the posture of the legs, the gestures with the hands and arms, the bodily expressions with which the person relates to the environment and to the people around her, and so on.

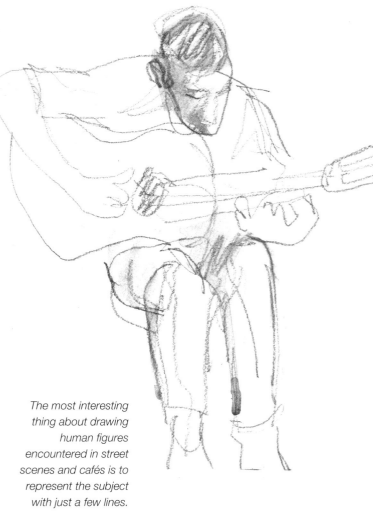

The most interesting thing about drawing human figures encountered in street scenes and cafés is to represent the subject with just a few lines.

Libraries and cafes are the best places to draw sketches, because the figures are relatively static.

To integrate or contextualize the figure with the surrounding space, it is advisable to include furniture that provides information about the environment.

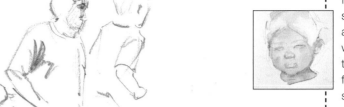

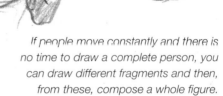

The faces of the figures in an interior space or in the street appear empty, without features, or in the case of a nearby figure, barely sketched.

PEOPLE IN THE STREET

In a busy place, such as a street with plenty of moving figures, it is a good idea to first draw people sitting, because they tend to keep the same position longer; then, once you draw the environment, you can draw the moving figures.

To sketch these figures, you should observe your subjects for a few moments, trying to memorize as much as possible of what you see. Then, with just a few lines, you should sketch everything you remember.

If people move constantly and there is no time to draw a complete person, you can draw different fragments and then, from these, compose a whole figure.

You must consider the distance of the figures. The nearby figures need to have a more defined profile and more detail. For a subject that is farther away, the silhouette fades and the face is emptier.

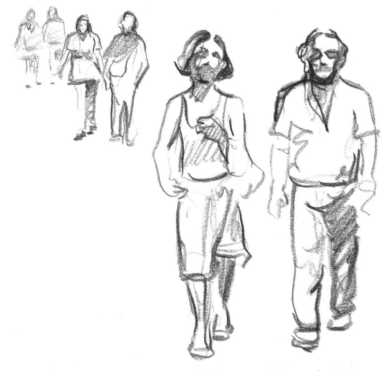

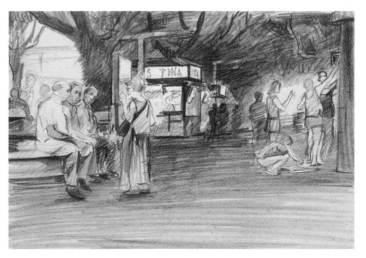

While the group of nearby figures is clearly distinguished, those in the background disappear and become integrated into the shaded landscape.

drawing animals is one of the most attractive and challenging subjects in sketching. The huge variety of creatures in the animal kingdom offers us an infinite range of shapes, structures, colors, and textures. The main inconvenience is that these subjects are continually moving, often in unpredictable ways.

drawing animals

PETS AND ZOO ANIMALS

The most accessible animal is a pet. Cats and dogs offer a large amount of poses and movements. A pet is an appropriate model for detailed studies, and our familiarity with our pets will add a touch of charm and character to the image.

Sketching zoo animals is very appealing for many artists. It is due, no doubt, to the large diversity of species that can be found in a zoo and to the fact that despite the relative freedom zoo animals have, their movements are limited and have a repetitive nature that allows the artist to finish or correct sketches.

A day on a farm can be very productive for sketching. If the animals are calm, you can sit down comfortably and try to draw with ink wash, ink, and a stick.

When drawing animals, you need to memorize the posture and to work fast. In this example, the artist has drawn the head and front part of the horse and improvised the back legs once the model moved.

If you have to work quickly, you can draw the head, which is more interesting and helps the viewer identify the species being rendered, and you can leave the torso and legs more sketchy.

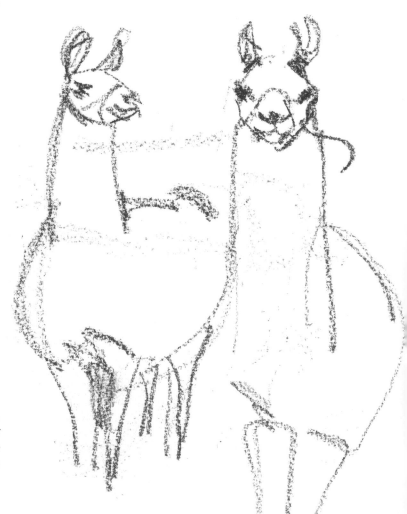

THE DIFFICULTY OF MOVEMENT

Drawing animals in their environment is not an easy task, because they move very often. Sketching while the creatures are moving might seem like an impossible undertaking. But there are ways to do it. The best way is to draw the basic lines in the drawing very quickly, trying to capture movements without worrying about anatomical perfection.

Another alternative is to work with a series of quick sketches that depict a series of movements or to draw over and over again on top of the first image to capture the changes in each action. The treatment must be done as an outline as much as possible, because the main purpose is to capture the rhythm and the significant lines of movement.

Exotic animals, insects, and amphibians are interesting to sketch because of the large variety of forms, attitudes, and colors that they offer compared to domestic animals.

The effect of movement can be achieved by drawing the same cat in different attitudes, as if it were a sequence of actions.

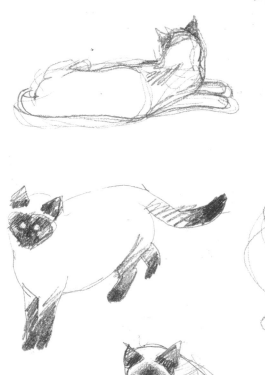

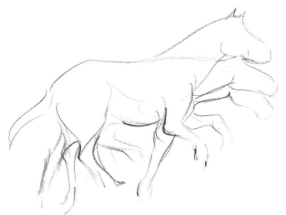

Superimposing several lines also creates an unstable form that conveys mobility.

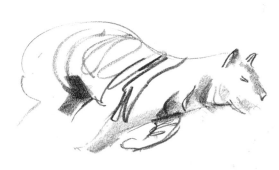

This is a sketch of an animal done with quick lines, with some unfinished parts and some blended parts of the anatomy, expressing movement.

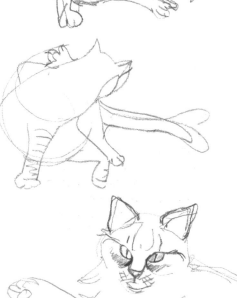

Unusual themes

there is a group of themes that for different reasons are not portrayed very frequently in sketching: still lifes, flowers, and portraits. The first two are constrained by the excessive stillness; the latter, because it requires a detailed work that resembles the person portrayed.

STILL LIFE

Sketching is very tied to exteriors, the outdoors, whereas still life is more appropriate for a studio, and less interesting for sketching. Still life is formed by everyday objects that do not require quick sketching, because they are static; you can sketch them calmly, using all materials within your reach. This subject is not very popular with professional sketch artists.

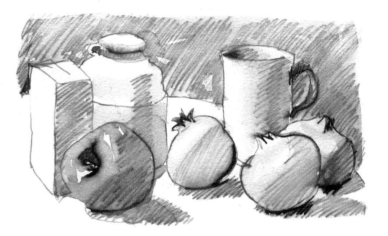

Among sketch artists, still life is not very popular because it is very common and static.

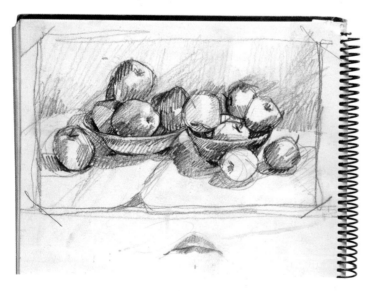

Still lifes are very common in art academies and schools. It is a good way to begin sketching, although it is not very stimulating for those artists who want to challenge themselves

Still lifes more appropriate to sketching include unusual scenes, themes with variety and action. For example, this is a sketch of a group of logs in a fireplace.

An unmade bed becomes an alpine landscape when you closely observe the folds and wrinkles in the sheets and comforter.

FLOWERS AND PLANTS

The same thing applies to still lifes with floral arrangements and garden flowers. Flower arrangements have the same static feeling of still life scenes, and, despite their color, they are not a very stimulating subject to sketch. Garden flowers tend to offer a more complex structure, and when drawing them, many artists make the mistake of paying excessive attention to detail. In this way, a sketch becomes a botanical-natural drawing.

The considerations regarding floral compositions are similar to those that apply to still life. One must avoid sketching subjects that are typically appropriate for a studio.

PORTRAITS

The most interesting thing about doing portraits is to capture detail in such a way that the persons being portrayed resemble themselves. Portraits require perseverance, constant modifications, a lot of patience, and dexterity. All these factors are contradictory to the dynamics of sketching, which is known for its brevity, spontaneity, expression, informal nature, and lack of precision. Only a very experienced artist can sketch a portrait with just a few lines and a couple of spots.

If you sketch a figure, you should avoid doing an actual portrait, because the meticulous and persevering nature of portrait rendering contradicts the spirit of sketching.

Step by Step

"DRAWING NATURE MUST BE JOINED TO AN AESTHETIC SENTIMENT THAT SELECTS, SORTS, SIMPLIFIES AND SYNTHESIZES. . . . IT MUST INSIST ON A LOGICAL CONSTRUCTION OF THE COMPOSITION, ON A HARMONIOUS DISTRIBUTION OF THE LIGHT AND DARK SPOTS, ON SIMPLIFICATION OF SHAPES AND PROPORTIONS TO GIVE THE CONTOURS A VIGOROUS AND ELOQUENT EXPRESSION."
Advice from Gauguin to Sérusier, 1888.

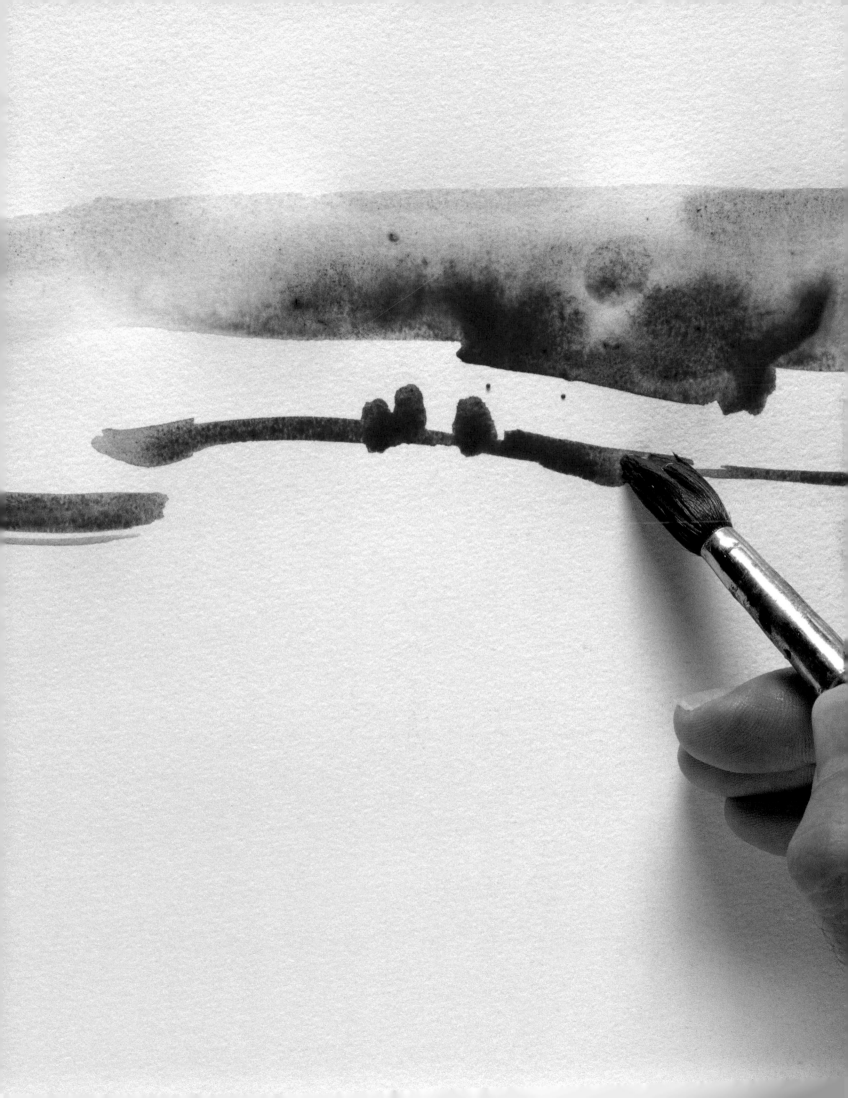

When you draw outdoors, you must first stroll for a few minutes about the area selected for your sketch, so you get an understanding of the position of the sun and so you can find interesting corners or places from which you can get a broader perspective of the scene.

Reject right away those subjects that are monotonous, that are against the light, and that are too open or too general.

Selecting the environment, finding the best frames

LOOKING FOR SUBJECTS AND CREATING FRAMES FOR THEM

The next step is to take your sketchbook and to study the possible frames, subjects, and different element groupings, to see which ones are more appealing. The first sketches are done with pencil, pen, and some ink wash.

A

B

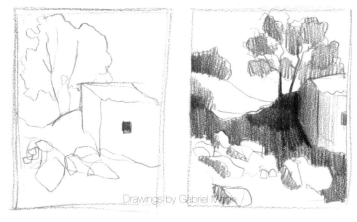

Drawings by Gabriel Martín

C

D

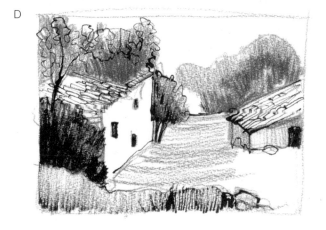

A. The artist sees a haven with a house that is partially torn down and some trees. He does a first sketch with a brown pencil. The treatment consists of just lines.

B. After analyzing his previous sketch, the artist decides to do another one, this time slightly modifying the frames. He places the house and the trees more to the right to unbalance the composition even more. A slight shadowing allows him to compensate for the unbalanced composition.

C. He climbs up onto a slope to have a higher position. With a brown pencil, he selects another frame, trying to achieve an asymmetrical composition.

D. He turns his head slightly to draw the same subject, this time emphasizing the elements on the left. With the application of shadows, the vegetation and the wall on the left get too much weight.

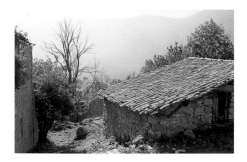

When sketching, it is advisable to "position" the subject, in other words, to detail the sketch as much as possible to identify the geographic spot—that is, the architectural features or the landscape—of a specific region.

1. As the sketches become more elaborate, the artist works with more perseverance those subjects or frames that attract his attention. In this case, the subject is first sketched with a thin line. The shadows are applied with a combination of a tone range with stripes. The artist uses a black pencil to highlight the main tone contrasts.

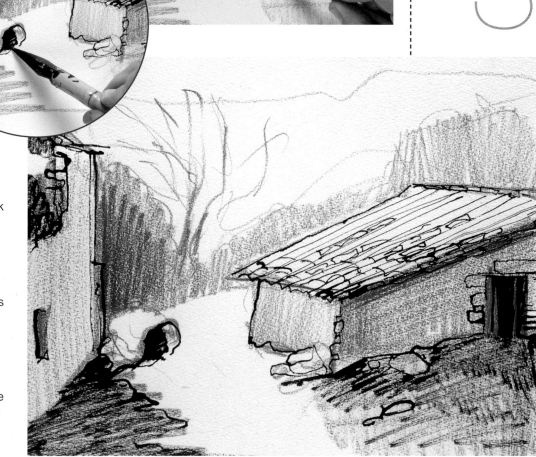

2. He combines the previous tone elements with lines done with China ink and a pen. The lines are only on the foreground and help highlight the profile of the houses and create the effect of texture on the roof.

3. After the artist draws some shadows with the pen and black ink, the sketch is complete. By highlighting the profile and increasing the contrast of the foreground, it looks more three-dimensional. The background must appear without any lines; otherwise, we would lose the contrast effect between the near and the far.

DEVELOPING THE MOST INTERESTING SKETCHES

The artist takes a few minutes to analyze the previous sketches and find interesting subjects in them that merit more attention. He is interested in the frame with the stone houses on both sides. However, he is not happy with the initial perspective of the sketch. On the spot, he looks at the real model again to continue work on the subject; now he cuts back the wall on the left, which emphasizes the house on the right, and he highlights the contrast of shadows with a sepia ink wash.

1. As in previous cases, the preliminary drawing is strictly outline and is done with a brown pencil.

2. With a sepia ink wash, the artist generously covers all shadowed areas in the landscape, except for the mountains, the roof of the house, and the grass, where he keeps the white color of the paper.

3. If the drawing is left in the sun, the ink wash dries in just a few minutes. Then, with a pen and India ink, the artist draws the profile of the old stone house, with short lines that convey the abrupt texture of the stone.

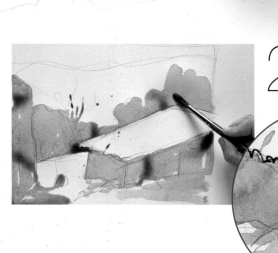

4. Then the artist works on the texture of the roof with lines of different thicknesses and contrasts the profile of the building on the left by applying frames of lines in black ink on the background vegetation.

5. The sketch is now complete. However, India ink may dilute and blend with the sepia ink if the artist applies another ink wash, now of a darker brown, over the black lines.

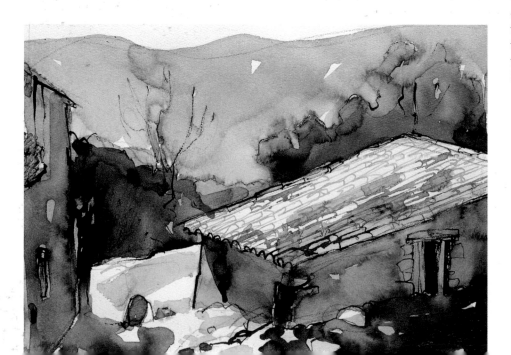

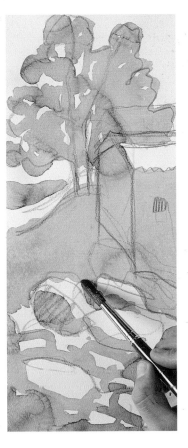

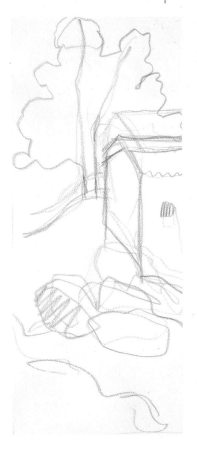

The line is the main vehicle that conveys texture in a drawing. To properly show the roof shingles, alternate the direction and change the thickness of the lines.

1. This time, the artist selects a very vertical frame to make the group of rocks in the foreground more important. You can see the touch-ups and continuous modifications on the roof of the house.

2. The shadows are applied very quickly. As they were before, the shadow areas are covered using a sepia ink wash. The blank spaces on the paper are the spots where the sunlight hits directly.

3. The following color process is done with a new ink wash in sepia brown, this time darker, that helps differentiate the plains of the nearest group of rocks.

4. When the paper is dry, the artist adds lines to the previous ink wash with a black pencil. This linear drawing highlights the shapes of the nearby rocks and introduces the effect of texture in the roof of the house.

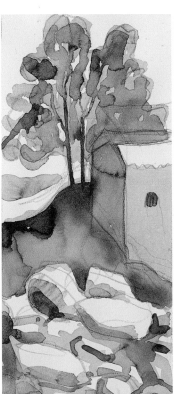

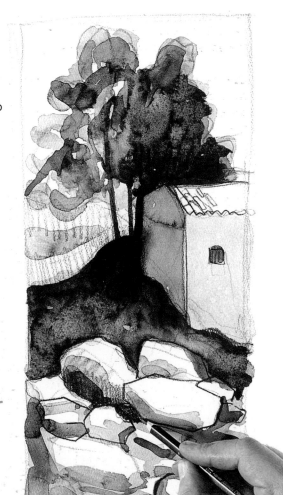

Comparative study
of different styles

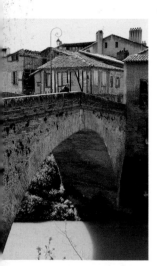

beginning with one model, three artists create three different interpretations, which are very much conditions of the techniques applied: linear resolution with a graphite lead, shadowing with a pastel stick, and a combination of lines and ink wash with ballpoint, marker, and brush.

THE VALUE OF COMPARISON

One of the main tools we have in sketching is comparison, the power of working different versions of one model by varying the means and treatment applied and then comparing the final result and selecting a specific interpretation.

1

2

Drawings by Mercedes Gaspar

1. In the sketch, the lines are very soft because they were drawn gently. The tip of the graphite lead is used to transfer to the paper the curvature and incline of the lines that define the bridge.

2. The curves of the bridge are reinforced by superimposing thicker lines on the previous fine lines. The group of houses in the upper part of the paper barely looks sketched. During this phase, you should work with the tip of the graphite lead to achieve finer lines.

3. The linear sketch was completed in the previous step. If you want to apply shadowing, the best way to do it is to apply gray areas by tilting the tip of the lead. The artist works here with three values.

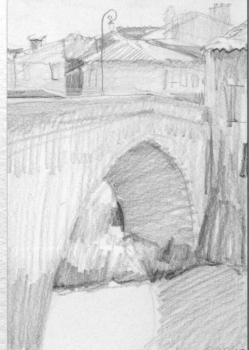

3

Before applying shadows, you must test the pastel stick to verify that it doesn't create broken stripes or a broken line. If it does, you can rub it repeatedly until it draws evenly.

SHADOW BLOCKS

The following interpretation is based on applying shadows using blocks or broad lines by sliding the brown pastel stick flat on the paper. The line is now the point of reference on the sketch over which the shadows are applied. It is the opposite process. Once the shadowing is complete, you can add some lines to make the composition more understandable.

1

2

1. With a brown pastel stick no longer than 1 inch long, draw the curvature of the arches of the bridge and the upper profile of the bridge. The shadows are broad, regular, and bold.

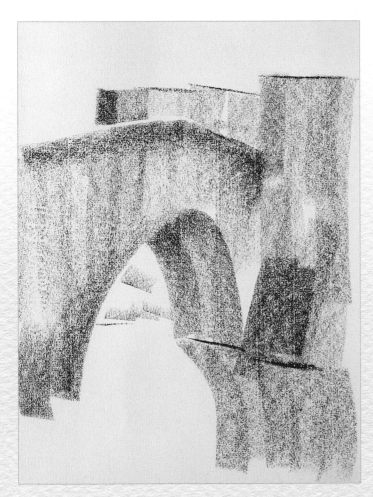

2. With these types of broad strokes you can complete the definition of the main architectural forms of the bridge and the edges of the river. The slightly granulated paper gives texture to each shadow applied.

3. Up until now, you have given priority to the contours of the shapes. Now, you should shade the inside of each of them with a light brown tone. To give coherence to the composition, all shadows are extended vertically.

3

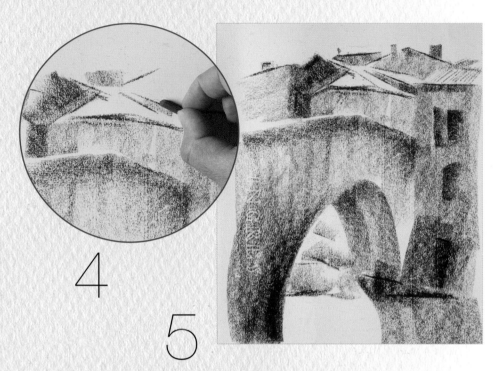

4. The lines that define the profile of the roofs of the houses are achieved by "dragging" the pastel stick on its side lengthwise. This process achieves very straight, fine lines.

5. Drag the pastel stick on the paper again, shading with the entire width of the stick to contrast the shadows of the facades of the houses and, in the foreground, at the onset of the arch of the bridge. The pressure applied to the line must be greater than that applied before.

Drawings by Óscar Sanchis

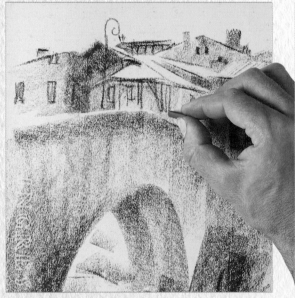

6. You can now use the tip of the pastel to make more precise lines on the facades, with short and cursory lines.

7. After a few lines, especially on the upper part of the sketch, you can consider the sketch complete.

1. The last sketch combined different techniques. Begin this drawing with fine lines, using a blue ballpoint. The most important thing is to draw the structure of the bridge and the profile of the houses.

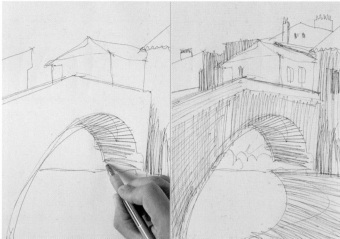

Softly using a paintbrush will suffice to achieve a wash effect with the ballpoint or marker. If you repeat the brushstrokes in the same place, you will fade the lines excessively, and the sketch will look more like a watercolor than a drawing.

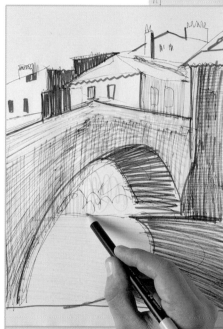

2. On the line drawing that you use as a guideline, use a stripe pattern for the shaded areas. This is formed by parallel lines, not very accurate, but effective.

3. With an ochre marker, shade the bridge and some facades. With a dark brown marker, give more intensity to the deep shadow under the bridge, passing over some profiles on the roofs of the houses and projecting new shadows on the buildings to achieve more contrast.

4. With a brush wet with water, wash the drawing. This will expand the colors (the blue of the ballpoint and the ochre and brown markers) and create soft transitions.

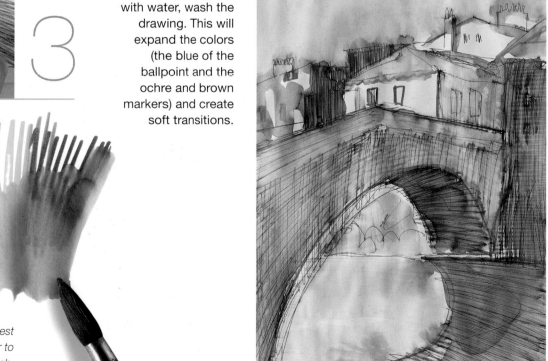

Before beginning to wash the drawing, test the effect on a separate piece of paper to see how it will look on the sketch.

extracting Details
from nature

drawing outdoors is not just drawing landscapes from an elevated point of view, or re-creating open spaces to find perspective effects. Sketches also are very interesting when we focus on small details, in corners of the natural world. Details may offer interesting tone effects or textures.

After a stroll, the artist finds a twisted tree trunk, ideal for sketching. He sketches the profile with a brown pencil. Then he adds the inside forms and makes a stripe pattern.

He reinforces the lines of the trunk by going over them with a pen and India ink. The purpose of this first sketch is to understand the model and own it.

1. The artist decides that the subject can be explored and begins a second sketch. This time the shadows have a greater presence and the lines are more precise.

2. To achieve more tones, he alternates the brown pencil with a gray one. With the latter, he highlights some profiles, shades the darkest areas, and superimposes the medium-gray shadows on others already covered with brown lines.

3. The drawing of the branches is very superficial. The artist marks some projections of the trunk, even when he is working with little details. He considers the sketch complete, leaving some zones unfinished.

Drawings by Gabriel Martín

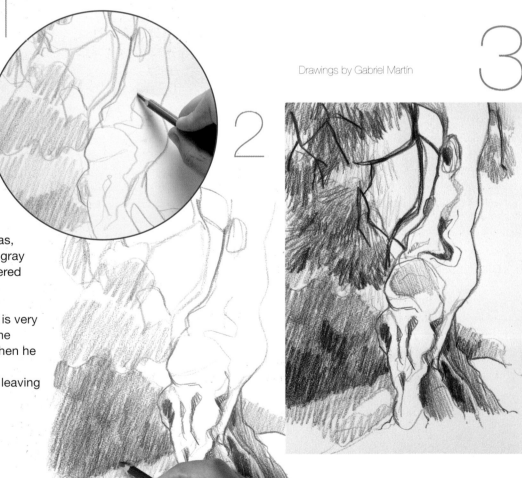

TWISTED TRUNKS

In a forest near to you, you can find interesting rocks or twisted tree trunks, full of holes, stripes, and textured bark. By studying these subjects, you can practice the combination of different drawing media and controlling the direction of the lines to adequately depict the volume and texture of the elements.

The shapes of the trunk are suggested by alternating light and dark zones. The tone range is important to achieve the effect of volume in each fold.

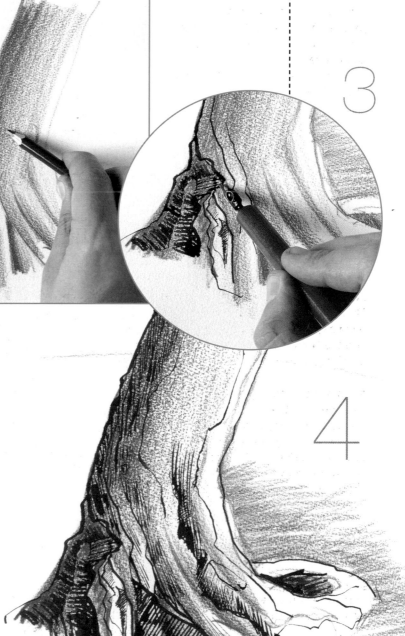

1. A few feet farther away there is another twisted tree trunk that attracts the artist's attention. With a gray pencil, he draws a contour highlighting and enhancing the effect of the root.

2. With the same pencil that he used to start the drawing, he shades the trunk. To achieve the cylindrical effect, he just needs to apply a tone range.

3. On the pencil drawing, he draws with a pen using China ink. Here he undertakes a more thorough study of the folds and textures of the bark of the trees.

4. The thicker ink lines depict the profile of the main folds and contours, while the thinner ones show texture.

Sketching
urban landscapes

an elevated position, sitting on the edge of a terrace, allows you to have a beautiful view of the roofs of a small central European town with low-rise traditional houses.

Everywhere you look you can see geometric shapes and superimposed planes. They will be the basis for the next set of sketches. Use a diagram, which is a simple rough draft with very geometrical lines, to evaluate the different possibilities of the frame and composition.

Drawings by Óscar Sanchís

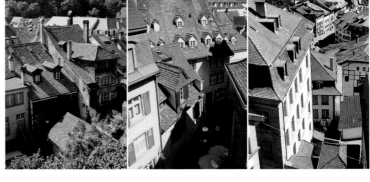

The elevated view over the city offers different possibilities for frames you can select. Any corner may suggest a good subject to draw.

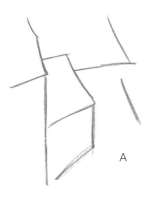

A

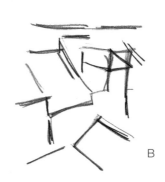

B

C

D

A. *The diagram allows you to approximate the first frames in very few lines.*

B. *The line does not need to be thin and smooth. Reinforce it by pressing on the pencil.*

C. *Focus on the profiles of the houses and ignore any element that is representative of the facade or detail.*

D. *It does not matter that the lack of architectural elements makes the drawing incomprehensible for the viewer. What matters is that you understand it.*

To accomplish clean outlines, it is best to alternate a graphite pencil with a colored pencil or Conte pencil.

In the sketches, any attempt at experimentation is welcome, as shown in the study of a group of roofs on the previous page; although this time the sketch is completed with a rectangular graphite stick. The thicker lines give more weight to the architecture.

You must avoid overcomplicating your urban sketches with repetitious lines, structures, or colors. The repetition of facades of historical buildings can lead to this mistake.

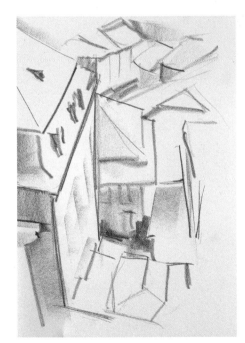

Beginning with the outline drawing created in the previous stage, study the building structure in more depth. In this sketch, the thickness of the lines varies depending on where the subject is situated, and some shadows appear, which helps the viewer to differentiate the various planes.

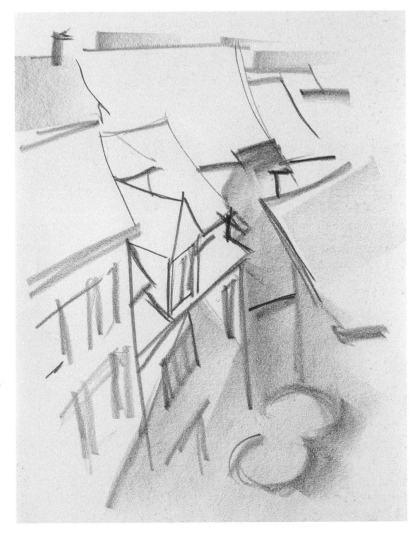

With a graphite lead, build the structure of the buildings. Vary the line, depending on the intensity of the light in each area. Then, use graphite lead to sketch the position of the windows in the nearest facades, which appear faintly.

After analyzing each of the possibilities offered by the subject, select one of the sketches previously done to develop a new sketch that includes light and shadow values.

1

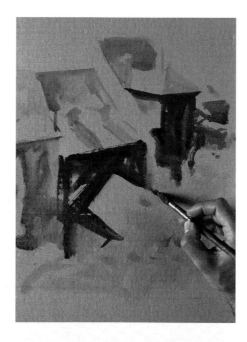

2

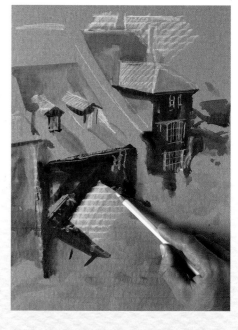

3

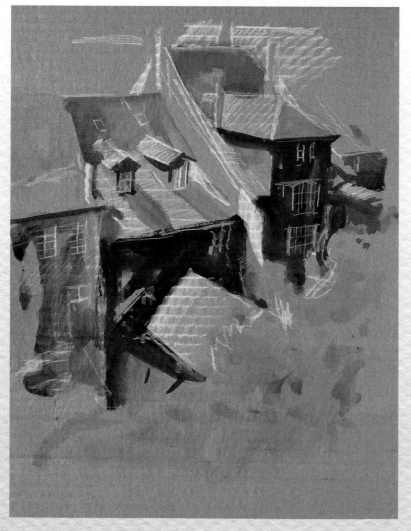

1. Given that sketches offer a good way to test new materials, instead of using a piece of paper, use a piece of cardboard. Without any previous drawing, represent the shadows with a sepia ink wash.

2. Once the ink is dry, with a white pencil draw some lines on the profile of the roofs, and highlight the areas that receive more sunlight.

3. A few lines drawn with white pencil express the position of the windows on the facades and mark the profile of the roofs. And the sketch should be left like that, to maintain its brevity and effect.

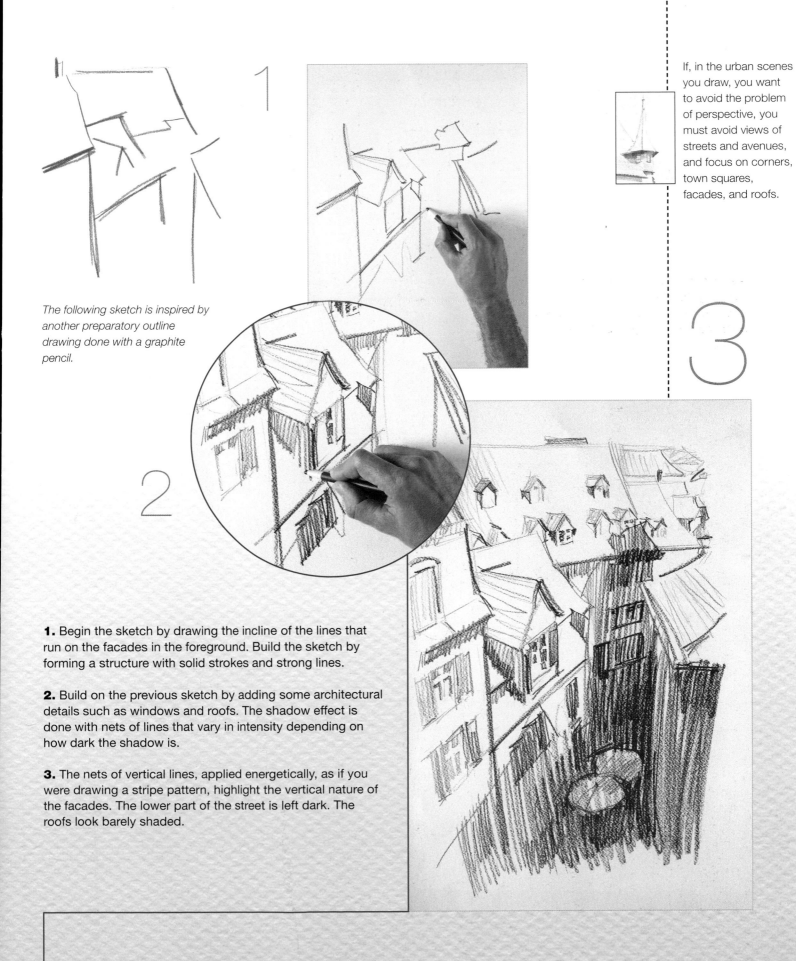

The following sketch is inspired by another preparatory outline drawing done with a graphite pencil.

If, in the urban scenes you draw, you want to avoid the problem of perspective, you must avoid views of streets and avenues, and focus on corners, town squares, facades, and roofs.

1. Begin the sketch by drawing the incline of the lines that run on the facades in the foreground. Build the sketch by forming a structure with solid strokes and strong lines.

2. Build on the previous sketch by adding some architectural details such as windows and roofs. The shadow effect is done with nets of lines that vary in intensity depending on how dark the shadow is.

3. The nets of vertical lines, applied energetically, as if you were drawing a stripe pattern, highlight the vertical nature of the facades. The lower part of the street is left dark. The roofs look barely shaded.

sketching Human figures

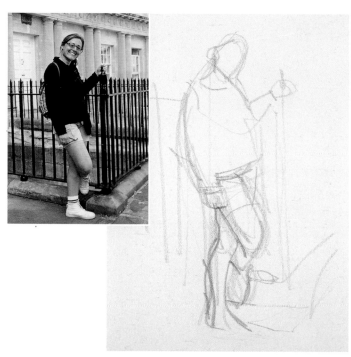

to learn to draw sketches of human figures, you must select your models carefully. You can begin by using your own relatives as models, in static poses, allowing you to work at your own pace.

Then, you can try to draw people on the street or people doing specific actions. The secret to drawing human figures properly is correctly establishing the preliminary drawing.

If you capture the pose with just a few lines, and highlight the lines of action and the internal body movement, you will have half the drawing done.

The profile of the figure has been done with very faint lines, except for the back lines of the legs, the back, and the line that joins the head and the lifted arm.

Drawings by Mercedes Gaspar.

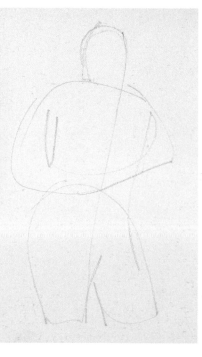

The most important step here is to use an outline to situate the oval of the head, the inclination of the shoulders, and the position of the arms, and to mark the position of the legs with an inverted "u."

Using as a guide the faint lines previously drawn, define the profiles with new lines, this time of medium intensity. At this point, stop, because it's a preliminary sketch.

1. Let's see another example, this time sequentially. The preliminary drawing has the sole purpose of framing and giving proportion to the figure. The lines are faint and unvarying in thickness and intensity.

In this sketch, the lines are more intense, marking the curved profile of some body areas. This helps describe the pose and give more mobility to the figure.

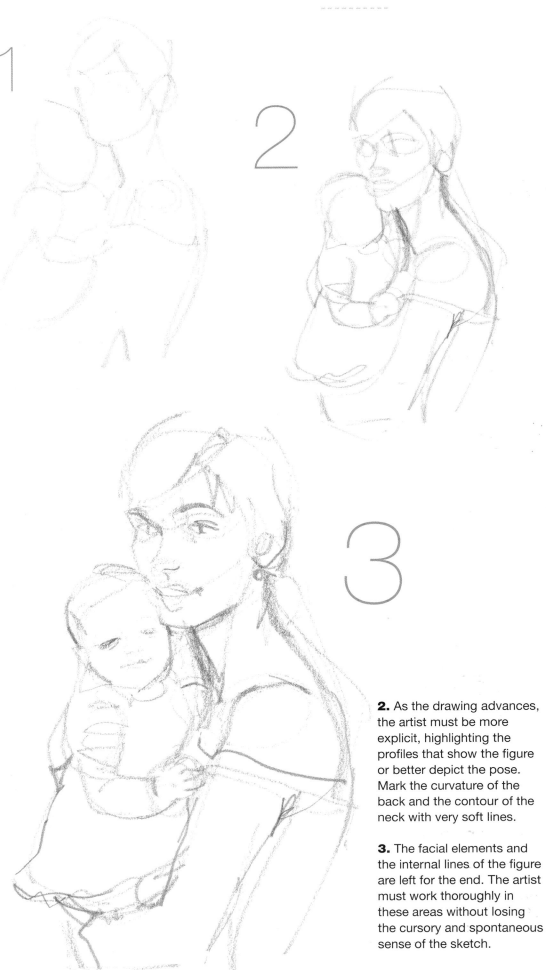

2. As the drawing advances, the artist must be more explicit, highlighting the profiles that show the figure or better depict the pose. Mark the curvature of the back and the contour of the neck with very soft lines.

3. The facial elements and the internal lines of the figure are left for the end. The artist must work thoroughly in these areas without losing the cursory and spontaneous sense of the sketch.

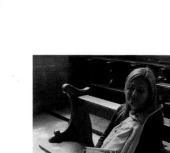

Once you have understood the importance of the preliminary sketch, try to draw a sitting figure. Because of the static pose of the model, you don't have the same urgency to act hurriedly.

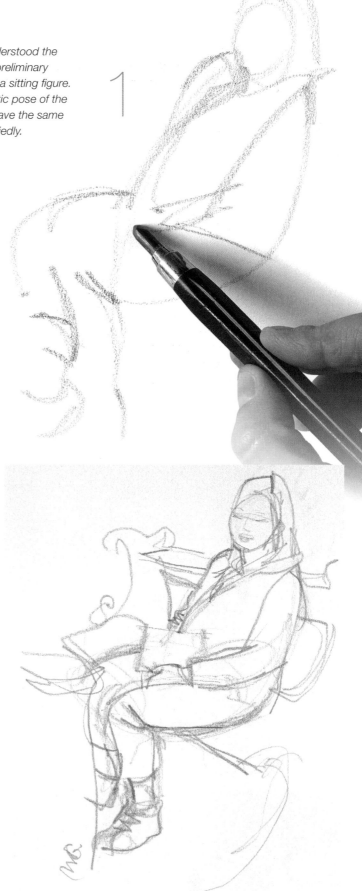

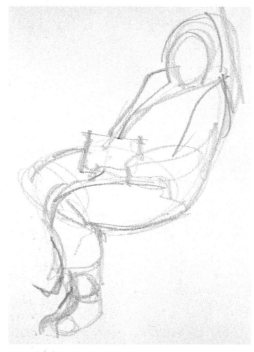

1. This sketch is done with a graphite lead. The seated figure usually takes on a zigzag position. The lines are soft and even, and the treatment is very cursory.

2. In the second phase, highlight only the lines that better describe the pose: the leg curvature, the upper profile of the arms, and the contour of the head and hair.

3. Finally, apply the internal lines, on the inside of the forms, to depict the folds, the position of the facial features, or the shapes of the shoes. With a soft line, sketch the bench where the figure is sitting.

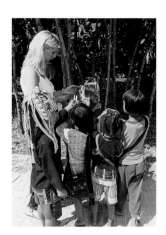

Let's finish our study of the figures with a moving model. When many superimposed people are present, the contours and shapes blend.

1. Work with two markers of different colors to verify how the formula of the preliminary drawing does not change even when you vary the tools used. Make the first approximation of the forms with a light brown color.

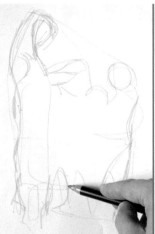

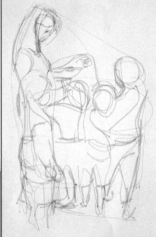

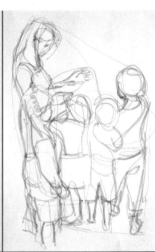

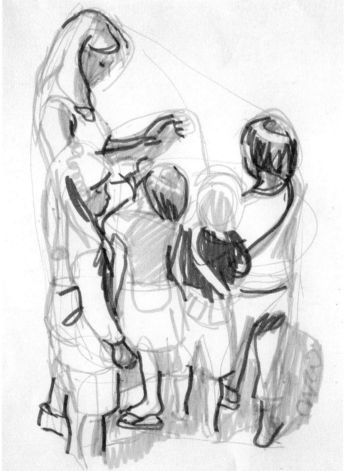

2. With the same color, mark the curves on the female body and the ovals and children's legs.

3. Place the lines and the pleats of some clothes, and define the arms and the position of the hands, all very cursorily, without getting into detail.

4. With a brown marker, highlight the rhythms and most distinctive internal lines of the figures, those that define the form of each figure. With these lines in place, the viewer will not become confused.

landscape with Ink washes
and lines

you are urged again to take up the subject of landscapes, which allow you to work more freely on less concrete forms than figures. It's also acceptable with landscapes to have a wider margin of error and a higher level of subjectivity than with sketches of other subjects. This exercise applies some ideas previously described about sketches that use ink washes. Ink washes allow the artist to apply shadows with different tones, depending on the amount of water added to the palette.

From an elevated position, the artist's point of view expands over a landscape of wheat fields where the land and the lines of the vegetation must contribute to the structure of the sketches.

 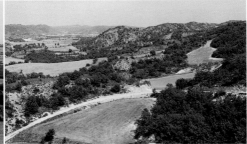

The first objective is to understand how the landscape is articulated. There is no better way to do this than taking colored or graphite pencils and beginning to draw very cursory forms.

The point is to work with different drawing methods, forcing yourself to create various frames, and analyzing the compositional varieties that the subject allows.

With a red pencil, try a new version, exaggerating the structure of the land. Remember, in the sketch the expressive quality prevails over proportion and detail.

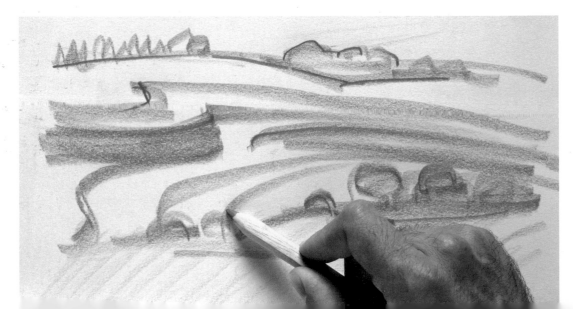

Drawings by Óscar Sanchis

Making sketches by alternating several inks of different colors enables you to experiment with colors to see how each one responds on the drawing paper used. The ink that offers the best results is the one that you should use to make elaborate sketches.

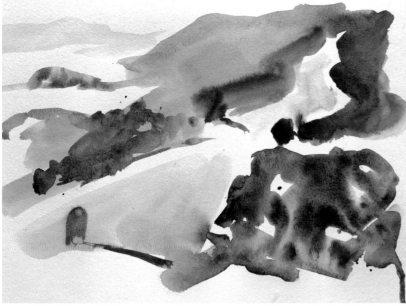

After a brief analysis of the subject using lines, continue with an ink wash in several colors. With a medium and very wet round rush and two tones only, you can depict the vegetation.

With sepia ink, repeat the previous frame, this time working on a more absorbent paper and gray color to give more emphasis to the rhythm of the landscape; add lines with brushstrokes.

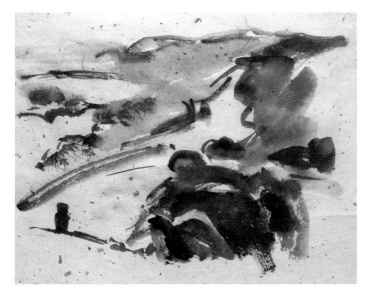

Study another area of the landscape. Once again, vary the color of the ink, looking for new results. Use a blue ink to shade the terraces in the landscape. The lighter areas are left in the color of the paper, untouched.

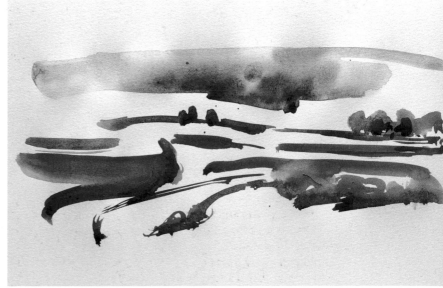

After the studies of the previous pages, choose the frame that you will work with blue ink.

1. Begin with the background. With slightly watered ink, paint the vegetation that crowns the top of the hill. Note that with this exercise you won't have practiced any previous drawings.

2. Over the previous blotches, draw new ones, in a more intense blue, that imply the presence of the trees. With a thick, round brush, place the tree on the left and paint the stone terrace covered by vegetation, which projects like a spot moving toward you.

3. Let the ink wash dry for a few minutes, and complete the sketch with a blue pencil. This requires minimal intervention: fill in the profile of the upper part of the hill, the silhouette of the tree on the left, and some action lines on the wheat fields.

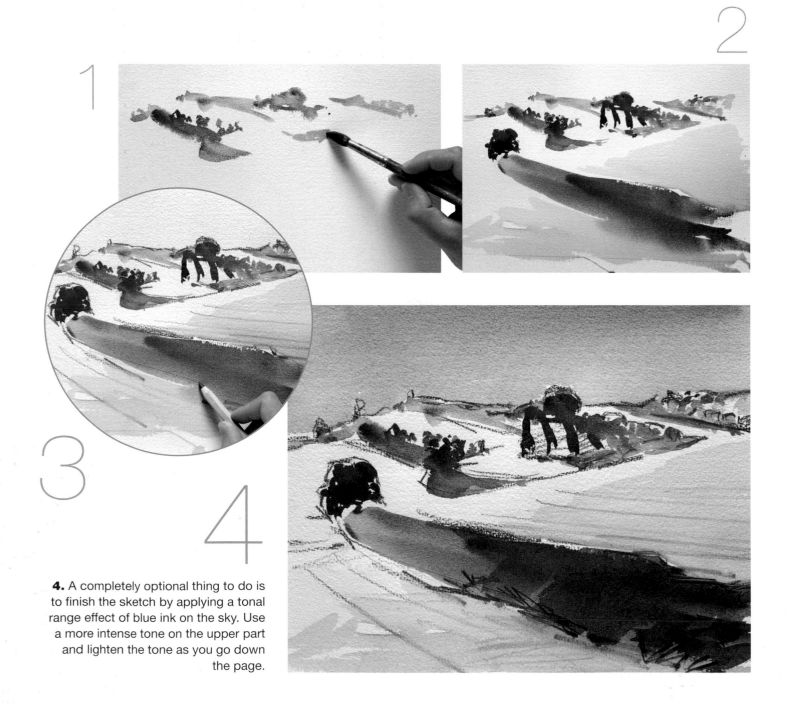

4. A completely optional thing to do is to finish the sketch by applying a tonal range effect of blue ink on the sky. Use a more intense tone on the upper part and lighten the tone as you go down the page.

1

1. Practice another frame of the same landscape again, this time with sepia ink. As in the previous case, begin with the forms farthest away, using watered-down brushstrokes.

2. Continue painting the terraces with variable tones, leaving small, clear patches corresponding to all the lighted areas of the wheat fields. Before the area dries, apply a darker color to the brush and tonally paint the masses of vegetation.

It doesn't matter if the form doesn't resemble the landscape exactly. The important thing is to pay attention to the treatment of the ink wash as a drawing tool.

2 3

3. The work with a colored pencil is now basically limited to a profile in the vegetation in the middle and some lines in the lower part of the sketch, next to the blotch marks.

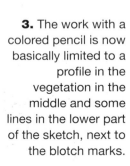

space, People, and ambiance

the best way to learn to draw a figure in an urban, architectural, or indoor setting is to draw its outline, sketching some quick lines that capture the spontaneous form and posture of the figure.

Even though many of these sketches are only in their early stages, they show the artist's intention. In this section, you will see several examples by Mercedes Gaspar, done with different materials.

A

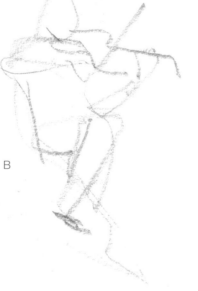

B

C

D

Figures integrated into an environment have very little definition, determined by almost a single line that shows the intention, the gesture, or the action of the figure, instead of showing details.

A. When sketching figures, you'd do well to start with the static ones. For example, if you work in an indoor setting, you should concentrate on the seated figures that, in general, adopt more expressive postures.

B. The sketch is quite simple in terms of execution. However, it requires a great process of synthesis by the artist. Begin with an oval for the head, followed by zigzag lines to describe the body's position and the shape of the violin.

C. Do the same thing to draw a passerby. A spot defines the head, and a soft and somewhat precise line shows the profile of the figure.

D. When the figure is facing you, put more emphasis on the arches of the arms and the incline of the lines that define the legs to properly describe the posture.

To apply the concepts learned on the previous page, re-create the figures in this indoor scene. It is a matter of capturing the essence of each figure in a very cursory and energetic manner to convey a busy feeling.

1

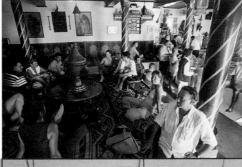

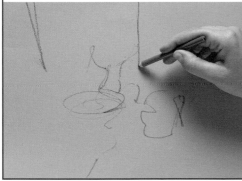

The highlights of whiite pencil or light color pastel are a very effective resource in sketches. They prevent the line from having too much weight in the drawing and from blending the forms.

2

3

4

1. Begin sketching with a sepia pencil, placing the basic lines that define the indoor space. Limit the columns on the background and indicate with an ellipse the position that will be the central table.

2. Begin with the most static figures. The line is very energetic and the drawing is very loose, fast, and indeterminate.

3. The people at the back of the room are rendered more geometrically. The male figure in the foreground requires a little more attention without the addition of more details.

4. Finish the sketch with a slight shadow; use a pencil that will help you define some forms by contrast. With a chunk of yellow pastel, apply slight highlighting on some areas to emphasize the volume (which shows the importance of using gray paper).

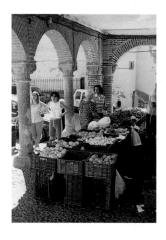

Let's study another brief sketch that integrates a group of figures in an architectural setting, in this case, the arches of a small rural market.

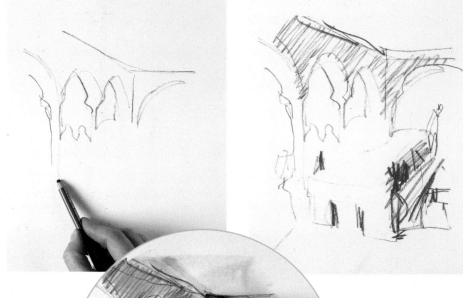

1

2

3

1. Begin by defining the architectural setting. With a charcoal pencil, draw the arches freehand.

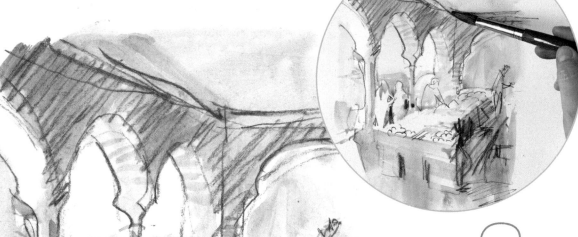

2. Once you have defined the arches, make the silhouette of the form of the group of figures and the space of the fruit stand in the foreground.

3. Over this drawing, dilute the charcoal lines with a wet brush. Maintain the light area in the first arch, the figures, and the fruit boxes in the same color as the paper.

4

4. This is the final sketch. Observe how the sketch gives the space around the figures more importance. These are completely integrated and are represented as if they were mere ghosts.

Let's try another challenge: achieving the feeling of more activity in people. Use the out-of-focus effect to show more mobility, working with charcoal and a blending stump.

In representations of urban scenes, the nearest figures show a greater number of lines than those that are farther away, which are barely silhouettes.

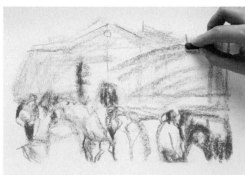

1. Working with a flat charcoal stick, roughly draw the profile of the building in the foreground. With a soft but voluptuous line, draw the masses that define the people.

2. To take away presence from the line on the building, shadow it completely until it becomes a large light shadow. The work on the figures is more precise and individualized.

3. With the blending stump, lighten some lines on the figures until you have made it look like parts of their profiles are out of focus. We alternate figures with very visible lines with others that seem vaporous to create the effect of movement.

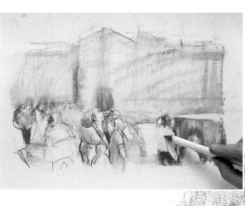

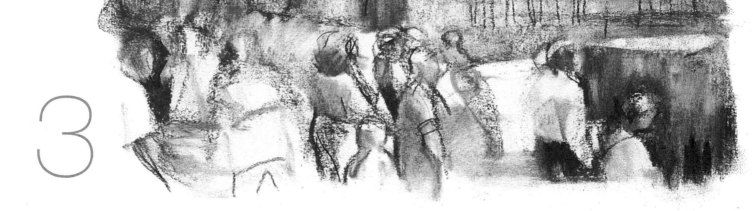

In the last exercise of the book, let's accompany the artist Gabriel Martín on an excursion in the mountains to see the sketches he makes during the day, the variety of techniques he uses, the subjects that attract his attention, and the degree of resolution he applies to each of them. This gives us a clear idea of the aspects that seem most interesting and allows us to obtain the maximum benefit from his sketches.

The first sketches are done with a marker. They are just outline sketches, preliminary sketches that describe the profiles of the buildings.

sketches and Notes from nature: a stroll in the mountains

A VARIED ENVIRONMENT

Our excursion starts in Moléson-sur-Gruyères, a small residential complex in the center of Switzerland. The panoramic views of the mountains, their forests, the rural architecture, and the changing aspects of the weather make this place an appropriate scene for our work.

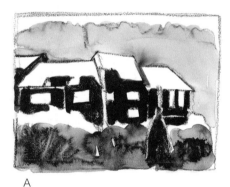

A

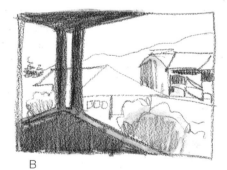

B

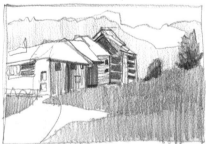
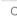

C

A. There is a fountain in the square. The artist takes advantage of this to make an ink wash of the black wood facades. These are the first sketches of the day, worked very cursorily.

B. We are under a balcony to achieve a more interesting frame, including the silhouette of the balcony in the view. Now the artist tries drawing with a sepia pencil, to which he will then apply a wash with the brush.

C. We walk away from the residential complex to have a broader perspective of the scene. For this sketch, the artist uses a 4B graphite pencil.

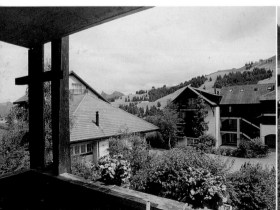
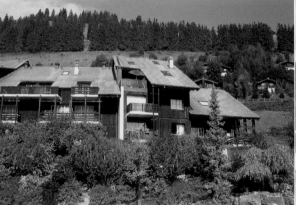
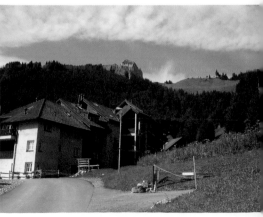

SKETCHING VIEWS

The artist takes a path up the hill that allows him to have a more elevated point of view of the residential complex. It's a good chance to see the panorama of the valley and to see how the architecture exists in the landscape. As we walk away from the houses, we notice an old wood building at the end of the housing complex. It's an old cheese factory.

A

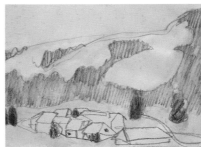

B

C

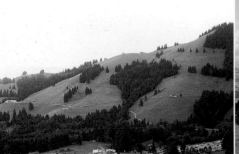

D

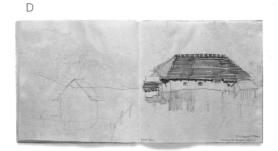

E

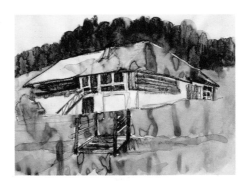

A. We continue up the hill. Now we have a broader view. With the sepia pencil, on the margin of a piece of notebook paper, the artist sketches a panorama of the valley.

B. We begin to walk up the path, which allows us to discover the mountain over the roofs of the houses. To achieve contrast, the artist treats the roofs linearly, and he uses gray tones for the mountain.

C. We look for a stone to sit on. He opens his notebook and draws the houses with a 6B graphite pencil, although this time he gives more relevance to the tone changes in the landscape than to the architecture of the place.

D. The artist goes close to the cheese factory, walking down a path. He takes a square notebook out of his backpack. He opens to a double page and sketches the scene. He only details and shadows the cheese factory, which has quickly attracted his attention.

E. The artist takes a new position, and on a piece of paper he draws the cheese factory with a pencil. He applies shadows to the trees and the windows with a marker. Then, with a sepia ink wash, he gives more consistency to the shadows.

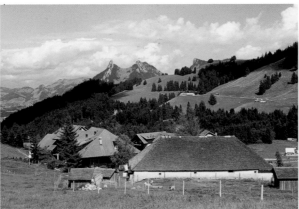

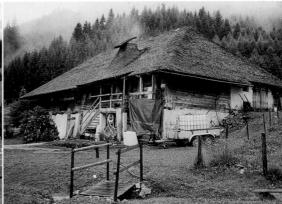

A

B

FARM ANIMALS

Next to the cheese factory we spot a group of noisy farm animals: rabbits, pigs, cows, and goats. It is a good opportunity to practice drawing animals, considering all the difficulties this entails. Animals are in constant movement and never follow our instructions

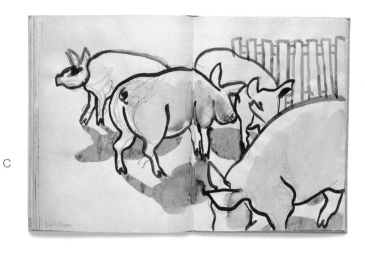

C

D

A and B. The first two attempts to draw the group of pigs are fruitless. The form of one pig is superimposed on another with lines and unfinished profiles.

C. After drawing for a while using the pencil, almost from memory, the artist achieves a good composition. To secure it, he contours the animals with a thick line achieved with a brush and India ink.

D. With the brush still in his hand, he takes a piece of paper that is more appropriate for the ink wash and draws some goats. He begins the drawings using a graphite pencil, very quickly and energetically. He will put the ink wash over the pencil marks, beginning with the black ones and ending with the sepia color.

E. We see that the pigs have gone into a wooden hut to rest. This is the best time to draw them calmly. For the first drawing, the artist uses a pencil, in case the pigs wake up and resume their activity. He will use this drawing as a base for the brown ink wash. Once everything is dry, he will go over the contours with a pen and India ink.

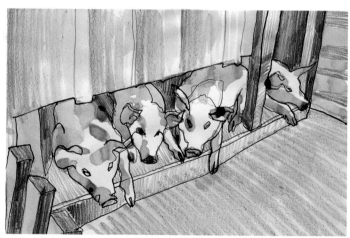

E

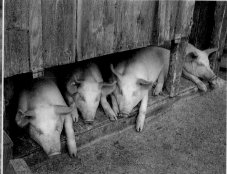
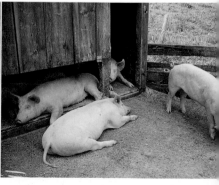

RUNNING WATER

Next to the cheese factory there is a creek coming from the mountain. This creek will be our main form in the next sketches.

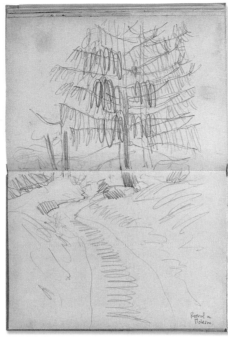

The artist opens a double page of the sketch book to sketch a corner that has gotten his attention. With a 6B graphite pencil, the artist quickly sketches a group of trees that flank the creek.

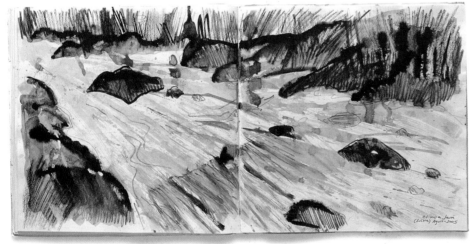

The sketch seems interesting enough to dedicate more time to it. On a double page of the sketchbook, the artist draws the creek bed with a carbon pencil. He opens a jar of India ink and begins to do an ink wash. To create the effect of movement and more expressivity, he shakes the brush in the air to spread blobs of black ink on the drawing.

We go up the creek. At a higher altitude we find new branches where the water runs more heavily. He draws the scene with charcoal pencil and India ink. The lines on the creek bed are fundamental to the representation of the amount of water and the speed of the water.

FORESTS AND MOUNTAINS

When we have almost reached the top of the mountain, we are surrounded by paths through thick forests. They look dark and impenetrable, so we decide to draw from the clear open patches next to the trees. This elevated position gives us a beautiful view of the nearby mountaintops.

A

B

C

A. Next to the path, with a charcoal stick and ink wash done with a brush, the artist draws a small sketch. This is a "first impression" of the forest.

B and C. We find a clear patch where we see a small area of the interior of the forest that is well lit. The artist begins two sketches, one done with a charcoal stick and the other one with a sepia ink wash.

D

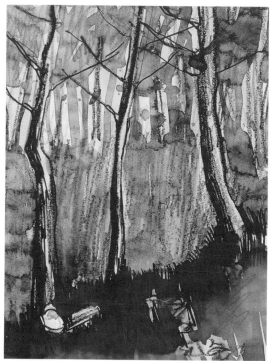

D. From both of these sketches the artist can obtain a new one with several combined techniques: charcoal stick (the background of the forest), marker (profile of the nearby trees and lower dark area), and ink wash (at the back of the forest and in the lower forest, in the foreground).

From our elevated position we can see the slopes of the nearby mountains. The light of the sunset gives special contrasts. The nearby clouds make the artist work hurriedly, and he barely has time to sketch a few lines with the brush and sepia ink.

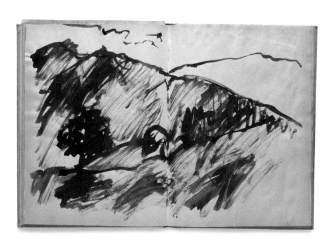

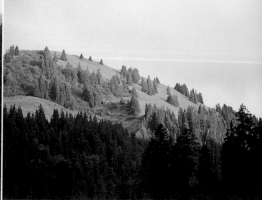

WEATHER CHANGES

The sketching day ends, and we are back at Moléson. On the way back, the weather changes very quickly, and the calm day turns into a cold and rainy afternoon; the fog literally invades the landscape. This new weather situation transformed the landscape, which previously had strong contrasts and bright colors, into a spectral view in which the only noticeable features are the diffused profiles of some mountains and trees.

A. *Despite the threatening weather, the artist stops several times to quickly sketch this new weather change. The first sketch is done directly with an ink wash.*

B. *In this variation of the previous sketch, the artist superimposes white lines on the dry ink wash to reflect the fog on the landscape.*

A
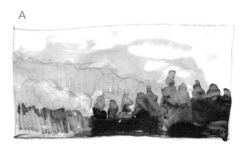

B
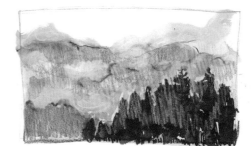

C

C. *The profiles of the distant mountains seem undefined and unfinished. The tops of the closest mountains have darker ink wash.*

D. *Every so often there are clear patches in the fog that allow us to see a group of trees. With a graphite pencil, he quickly sketches their shape.*

D
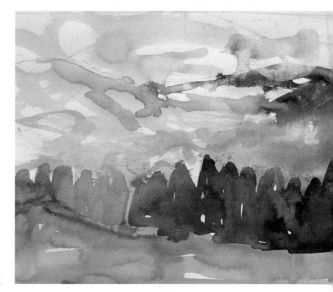

E. *We are almost back at our starting point, and the artist stops once more to do his last sketch, a free ink wash reflecting the weather changes. The amount of ink in the ink wash is less every time, which reduces the contrasts, and the sky is sketched with broader and more energetic brushstrokes.*

E

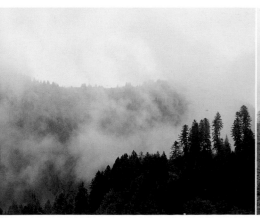
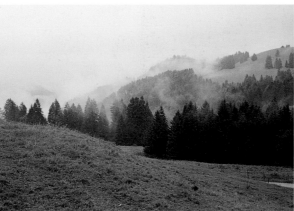
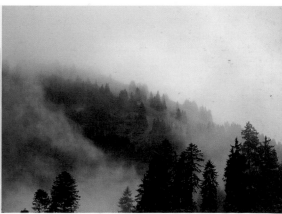

A

Atmospheric perspective. Effect of the atmosphere that fades colors with distance, as they are farther away. toward the horizon.

B

Blending. Soft and continuous tone reduction of a charcoal, graphite, or pastel spot. Blending can be done with your fingers, a blending stump, or a rag.

Blending stump. Spongy paper tube used to spread and reduce charcoal, graphite, and pastel spots.

Blind drawing. Drawing technique that consists of not looking at the paper while drawing. The eyes looks at the subject while the hand draws the contour on the paper.

C

Composition. The art of organizing a drawing or painting with balance and harmony.

Contour. Drawing in which the exterior line of the objects, often curved, is very important and helps define the shapes.

Contrast. Noticeable opposition between two distant tonal sensations.

Creta. Generic name of lead or hard pastel sticks in white, black, sanguine, or sepia colors. The name comes from a white lime rock.

D

Diagram. Preliminary drawing that reflects the basic structure of the bodies using very cursory and geometrlc-like shapes.

Drop. Spot made by a large drop of ink to add expressivity and spontaneity to the drawing.

F

Frame. Selection of a significant portion of the model based on the format of the paper on which it will be drawn.

G

Grain. Texture on the surface of the paper. It can range from smooth to rough.

H

Highlight. Line in a light color that stands out on a dark background. Highlights are done on drawings on color paper.

Horizon line. Straight line where the land or the sea meets the sky. It is always at eye level.

I

Ink wash. Drawing technique with ink or watercolor pencils consisting of extending spots of ink with the brush.

M

Merging. Smoothing the contours of two tones, mixing them to form a slight degree of tonal variation.

Modeling. Sculpture term used in drawing to indicate shading achieved with several tones, with smooth transitions and without strong contrasts. It is not used very often in sketching.

N

Net pattern. Network of lines creating shadows. It is the typical technique in pen drawings

P

Point of view. Observation point or angle chosen to paint a subject. Each different point of view offers new compositional possibilities.

Proportion. The ratio of one part of a work to the whole work or to other parts of the work.

R

Rough draft. Early stage or practicing stage of a drawing or painting from which the final painting will be created. It is done with just a few lines, enough to capture the essential lines of the drawing.

S

Shadow blocks. Drawing technique based on creating silhouettes for each shape by drawing tone masses in a solid color.

Staining. Drawing process consisting of spreading generic stains all over the page to achieve a first approximation of the subject being drawn.

Symmetry. Drawing composition defined as the identical repetition of elements on both sides of a central axis.

T

Texture. Tactile and visual quality that can appear on the surface of a drawing or painting. It can be smooth, granulated, rough, or quartered, and it is always perceptible.

Tone. Degree of intensity of a color in comparison to the grayscale.

Tone range. Area of the drawing with a progression of the intensity of a tone.

Tone technique. Drawing technique based on contrast between tones rather than on line contours.

Touch-up. Repeated superimposed strokes, not erased, to perfect the outline in a drawing.

V

Value. Tone intensity compared to other intensities. Shadowing is based on the contrasts of values.

Valuation. Drawing process by which different degrees of light and shadow are created, reducing or intensifying the values of the drawing.

W

Wash or ink wash. Application of an extensive layer of color. It can be even, or it can have a tonal range variation.